TELSTAR

Nick Moran with James Hicks

TELSTAR

THE JOE MEEK STORY

OBERON BOOKS
LONDON

WWW.OBERONBOOKS.COM

First published in 2005 by Oberon Books Ltd
521 Caledonian Road, London N7 9RH
Tel: +44 (0) 20 7607 3637 / Fax: +44 (0) 20 7607 3629
e-mail: info@oberonbooks.com
www.oberonbooks.com

Cover image and title design by AKA

PB ISBN: 9781840025880
E ISBN: 9781849439640

TELSTAR

The play, its history, and how it should be played

Telstar began life in the mid-'90s when two unemployed actors and ambitious writers looking for material stumbled upon a relatively unknown true story. A series of fortunate flukes and bizarre coincidences brought them to a gold-mine of drama, loss, humour, heartbreak and tragedy. Here was a story, that – if properly told – should be both a time-capsule of a nation waking up to a new era and a timeless tale of one man's struggle to control his emotions as his empire destroyed him.

After the initial inspiration of seeing a memorial plaque on a house outside 304 Holloway Road that intriguingly read

JOE MEEK LIVED, WORKED AND DIED HERE

the extensive research was fast-tracked by the fact that James Hicks' grandmother was a close friend of Alan Blaikley, Joe's writing partner for many years. As the research intensified the two writers delved into stories from the living to bring the dead to life.

Apart from the usual research into documentaries and any available literature, they were also invited to various Joe Meek conventions in North London pubs, meeting with the members of Joe's bands and his business associates. It seemed everyone had an amazing Joe Meek anecdote. All the characters around Joe and the parts they played in his life gradually showed a way of bringing this story to a theatrical life.

The problem then became how to tell a story spanning about five years in two hours without bending the truth. It would be unfair for the writers to take any credit for the story itself: all the characters involved in Joe Meek's life were already colourful and the true events around his triumph and downfall were beyond the creation of the most imaginative mind. Over many months Nick and James improvised the scenes to bring the people and the period to life, structuring

the play as they went along. They both then sharpened the dialogue and edited it together.

The play revolves around six recording sessions in the studio – all one day long and one year apart – each scene telling the story of what happened the year before and making the audience aware of what had gone wrong. The biggest dilemma was choosing which characters to lose and which ones to favour. It is safe to say that the first draft was considerably longer than the finished play! But each and every character had back-story that – if not mentioned – still brought depth to the characters and richness to the plot. This is something that future actors and directors may like to delve into if they want to get the most from the piece.

The first reading of the play was performed in a disused pub in Stockwell (with the help of Kathy Burke, Jude Law, Samantha Morton and a handful of other unknowns at the time). Con O'Neill read the part of Joe, as he did in every incarnation of the play until it made it to the West End. It subsequently moved with the help of Paines Plough under the watchful eyes of Sir John Mortimer and Mark Ravenhill, and was presented later that year at the Bridewell Theatre London as a public reading to a healthy reception.

After several other airings it was picked up by New Vic Workshop and – with the meticulous help of Tony Milner and funding of the Arts Council of England – premiered at the Cambridge Arts Theatre in February 2005, some eight years after the writers had drunkenly stumbled out of a taxi under the plaque on the Holloway Road.

There is a saying that there is no right or wrong way of doing things in theatre; there is only what works. With *Telstar* this is not necessarily the case. Any future productions should remember that the people here are or were real. The play is a factual account of historical events, and care should be taken to present the play in a way that honours the aspirations, joys and sadnesses of the characters depicted here. None of these characters is an object of fun, and their concerns are genuine. We believe that the company has an obligation to the living

and deceased to treat this play with the reverence and honesty with which it was researched and written.

It would be unfair not to mention the tremendous inspiration of Chas Hodges, Patrick Pink and Clem Cattini, not only as a source for information, but also as a great insight into the type of characters of the time.

For further insight, just watch *The Lambeth Boys* (a documentary by Karel Reisz) and Joan Littlewood's film *Sparrows Can't Sing*. Please also read John Repsch's book *The Legendary Joe Meek*.

This play is obviously dedicated to Joe and all those who help to keep the story alive.

Nick Moran and James Hicks, June 2005

Note This play is based on real-life events and people. Nevertheless it is a created, dramatic work and as such is not an exact historical record. Any misrepresentation of persons living or dead is unintended.

Characters

PATRICK PINK

TWO POLICEMEN

GEOFF GODDARD

MRS VIOLET SHENTON

MAJOR BANKS

JOE MEEK

CLEM CATTINI

CHAS HODGES

BILLY KUY

HEINZ BURT

JOHN LEYTON

ALAN CADDY

JOHN PEEL

LORD SUTCH

RICHIE BLACKMORE

ALAN BLAIKLEY

SIMON

BAILIFFS

Telstar was first performed by New Vic Workshop at the Cambridge Arts Theatre on 2 February 2005, with the following cast:

CHAS HODGES, Tarl Caple

GEOFF GODDARD, Gareth Corke

JOHN LEYTON / LORD SUTCH / SIMON,
 Callum Dixon

BILLY KUY / ALAN CADDY /
 RICHIE BLACKMORE, David Hayler

PATRICK PINK, Roland Manookian

JOE MEEK, Con O'Neill

HEINZ BURT, Adam Rickitt

MRS SHENTON, Linda Robson

CLEM CATTINI, William Woods

MAJOR BANKS, Philip York

Director Paul Jepson
Designer Tim Shortall
Lighting Chris Ellis
Sound Martyn Davies
Casting Kate Plantin
Fight Director Terry King

ACT ONE

Prologue

The lights come up on PATRICK PINK in a tightly lit spotlight just left of the of the main set. He is young, twenty-two, with boyish good looks. He is under much stress and is smoking. He is flanked by a silhouette of two burly policemen. One is asking questions; the other takes notes.

PATRICK: He was angry about something. I've no idea what. He was paranoid, tense and angry. I was going to call for the doctor but he stopped me.

POLICEMAN: A doctor. Why would you do that?

PATRICK: Because…he was…like I said…

POLICEMAN: I See. Carry on son.

PATRICK: Then he give me a little note saying, 'I'm going now, Good-bye.' I didn't know what it meant. Cause then he was upstairs playing tapes from the night before, I thought, well everything's all right then. Then Michael and his little mate arrived, I went to the door and shouted, 'Michael's here.' He called, 'Tell them to fuck off.'

POLICEMAN: You said that?

PATRICK: No, he said…it…

POLICEMAN: Oh, I see. So they went off…

PATRICK: …then he says, 'Get Mrs Shenton up here.' She said, 'What's up?' I said, 'I don't know, Joe want's you.' She said, 'Hold this for me a minute I don't like to smoke up there.' I took the cigarette off her. I thought everything will be OK now, she'll calm him down. Within about half a minute there was a lot of shouting.

POLICEMAN: Who was shouting?

PATRICK: Just him. I heard him say, 'Have you got the book?' God knows what it was. The rent book, or lease or something. He was going frantic. The shouting went on. I was downstairs when I heard it. A bang.

POLICEMAN: Get your facts straight son. What sort of bang?

PATRICK: I didn't know what it was. Just a fucking big bang. I was stunned. I rushed into the studio and she fell towards me, and I sort of grabbed her. I wondered what it was for a minute. Then...then I saw the blood pouring out of these little holes in her back. I had blood all over me. I just sort of pushed her over and shouted, 'She's dead.'

POLICEMAN: What about the second shot?

PATRICK: Joe just looked at me with this stony cold look. He was outside the control room, reloading. He walked upstairs, I sort of followed him, then he turned away, and there was this blinding flash.

POLICEMAN: And who had the gun?

PATRICK: And there was Joe's body, with a head like... like a melted candle. Blood Everywhere. There was blood everywhere. I was treading in blood.

POLICEMAN: *(Stops writing, looks up.)* Patrick Pink, I am arresting you on suspicion of murder. You do not have to say anything. Anything you do say may be used at your trial.

As the lights fade out on PATRICK, they slowly start to rise on the rest of the stage. We see a small incredibly cluttered studio, consisting of a small windowless control room, packed senseless with reel-to-reel tape machines and spools, a main studio room strewn with cables and DI boxes, microphone

stands and various amplifiers, a short hallway leading to a toilet, and a stairwell leading up and downstairs. There is a door from the landing to the studio, and another door from the studio landing to the bedrooms upstairs.

From inside the studio a small bakerlite radio bursts to life. We hear a montage of news clips telling us that it is summer of 1961. It ends with 'Angela Jones' by Michael Cox. Fade out.

Scene 1

GEOFF GODDARD, an intense, distant and nervous looking man in his late-teens / early-twenties, enters. He has a dark well-groomed quiff, and is slightly wet. He takes off his raincoat, and hangs it on a coat stand near the door. He is wearing a smart suit of the period. It is 1961. He is very ill at ease, and circles the room looking for any sign of life. He approaches the piano in the corner, and tensely plays a few chords. The piano has a hard metallic unusual sound. As he plays he unconsciously makes strange grunting noises.

VIOLET SHENTON, a stern, sturdy-looking woman in her late forties enters and startles GEOFF.

MRS SHENTON: Who are you then?

GEOFF: I'm… They're doing my song.

MRS SHENTON: Well I'd like a word with Joe about my ceiling.

GEOFF: I'm sorry, I can't…er…

MRS SHENTON: That's my shop downstairs.

GEOFF: …can't…

MRS SHENTON: I'm the landlady.

GEOFF: …help.

MRS SHENTON: Pardon?

GEOFF: Can't help…only just… I don't know where he is.

MRS SHENTON: *(Looks round.)* They have been busy ain't they. Proper little Trojans. No daylight is there. It'll get ever so dreary. Glad we've moved to Barnet.

GEOFF: Mmmm.

MRS SHENTON: *(Pause.)* So you don't know where he is then.

GEOFF: No.

MRS SHENTON: And you've not seen the other one? The toff?

GEOFF: No. No I've not...toff who?

MRS SHENTON: Sure you've not just come in off the street?

GEOFF: No I... Well, technically yes but I...

MRS SHENTON: They've had all sorts up here. Still long as they keep themselves to themselves. You're a quiet one aren't you.

GEOFF: Sorry. *(Pause.)* Just a bit...

MRS SHENTON: Shy.

GEOFF: Well, nervous really. You see, Biggles is singing my song. *(Silence.)* Biggles, off the telly.

MRS SHENTON: Of course he is. Tell Joe I need to see him. I've had a bleedin disaster downstairs.

GEOFF: Oh dear...

MRS SHENTON: Well it's all the noise and banging. We've already had some terrible complaints from the neighbours, without the latest...incident. There's a big sticky mess all over my ceiling.

GEOFF: Oh. Could be ectoplasm.

MRS SHENTON: No it's not eggs dear. Recording studio. Grown men playing silly buggers with grammerphone records. I only hope it doesn't all add up to nothing.

GEOFF: Well I've already bought two…

MRS SHENTON: This used to be ever such a nice flat when we lived here. I'm not going to be able to rent it out now am I? Cheer up, might never happen. Here, we've got some nice ox blood belts in, match those brogues lovely. I can let you have 'em cost.

On her way out the door she bumps into MAJOR BANKS. He is a stout man in his late forties, about 5' 8", very smartly dressed with a large erect ginger quiff and moustache. He has an almost caricature military manner and a wry charm.

MAJOR: Sorry Violet dear.

MRS SHENTON: Oh, hello. You'll do. Look I've had a disaster downstairs in me stock room.

MAJOR: Oh, Lord. I've just arrived. No sign of Joe is there?

GEOFF: Er…no.

MAJOR: He's yer man. Well, Violet dear he will be sent down as soon as he is sighted.

MRS SHENTON: Thank you.

MAJOR: Well, busy day. Must crack on.

MRS SHENTON: I'll go back down and inspect my ceiling.

She leaves.

MAJOR: Anton, isn't it?

GEOFF: Sorry?

MAJOR: Anton Hollywood. The pianist.

GEOFF: Yes. Well, no Major, sir.

MAJOR: I'm afraid Joe's decision is final. *(Starts to show GEOFF out of the room.)* He feels you've not got what it takes, and if you've come for compensation you best trot along back to where...

GEOFF: No. It's Geoff. Well not just Geoff, Geoff Goddard.

MAJOR: Oh, you're also an author...er...tune-smith.

GEOFF: Composer.

MAJOR: Composer, of course.

GEOFF: The name Anton Hollywood was Joe's idea, it's not real, it's just a stage name. He thought he could do a Russ Conway with me...

MAJOR: Read Goddard, didn't think Hollywood.

GEOFF: No, you wouldn't.

MAJOR: Don't slouch sonny. Upright. Straighten your back you can look a man of six foot in the eye.

GEOFF: Yes. Major, sir.

MAJOR: Splendid song.

GEOFF: Thank you. In fact I wanted to thank you for the opportunity really. This is a very good...opportunity, and er well, I just wanted to thank you.

MAJOR: Very touching, but Joe is the person to thank. I know sweet Fanny Adams about the tunes. I'm in plastic.

GEOFF: Really.

MAJOR: Got a son you see.

GEOFF: Really?

MAJOR: Took me to a record shop. Couldn't believe it. Selling like hot cakes that Lolly...er...Larry...er you know, curly hair, big nose, plays a broom.

GEOFF: Donegan. Lonnie Donegan.

MAJOR: That's the one! Records. Expanding market. Business opportunity. Met Joe, thought that's my boy. Knows his Indians. Anyway it's him you should thank, if we ever find him.

There is the sound of a flushing toilet, followed by the buzz of an electric razor. The door to the bathroom at the end of the hall at the back of the studio opens.

JOE MEEK leans out of the doorway, he is shaving with an electric razor on a very long spiral lead. He is thirty-two, of short, but barrel-chested build, he is smartly dressed in a well pressed suit, his hair perfectly groomed into a small quiff. Upon close inspection one might notice his face is faintly powdered and he is wearing very subtle eye make-up. He speaks in a high but fey voice with a slight Gloucester accent. He has a vague but intense air about him which can make him shockingly direct.

JOE: Hello Geoff. Do you shave often?

GEOFF: Not really. I...er... A couple of times a week.

JOE: Morning noon and night, me. Could you pass me the mike stand. I've the backing singers in there in half an hour, so if you want to go, go now...

GEOFF: No. No thank you Joe.

JOE: When I add my reverb sound more like a cathedral than a toilet.

MAJOR: Talking of which, backing singers that is, do we need them?

JOE: Of course we need them.

MAJOR: And an orchestra?

JOE: Hardly an orchestra, it's one violin and Charles on his mum's old cello. *Harpers West One* is the BBC's top show. It's getting ten million viewers. They're all going to hear Geoff's song. It's a good chance for a hit, so it can't be shoddy. *(To GEOFF.)* Have you read the *West One* script?

He shows GEOFF the script briefly, then snatches it back.

GEOFF: No.

JOE: Well, John Leyton is playing a pop singer called Johnny St Cyr, good name that don't you think, and he opens the record department with your song.

GEOFF: Who'd've thought… Biggles.

MAJOR: He's Ginger!

GEOFF: Really?

MAJOR: In Biggles. John Leyton. Plays Ginger. The boy's a big fan. Looking forward to meeting him. Of course I was in Burma, transport, and…

MRS SHENTON: *(Voice off.)* Joe. Are you coming down?

JOE: Can you talk to her I'm far too busy now.

MAJOR: Yes, let you crack on. Pleasure Geoff. I'm sure we will be seeing a lot more of you. Violet on my way.

The MAJOR gives GEOFF a hearty hand shake and leaves. GEOFF stands to attention.

JOE: He gave you that speech about not slouching, didn't he.

JOE starts to position microphones, and microphone stands.

GEOFF: Can I help?

JOE: No not really. I know exactly what I'm doing. Unlike some people.

GEOFF: I'm sure it will sound wonderful. I…er…wanted to thank you for this opportunity.

JOE: Oh, you don't have to thank me Geoff, it's a good song that's all there is to it.

GEOFF: I loved 'Put A Ring On Her Finger'. It's very catchy.

JOE: Did you buy the 'Les Paul and Mary Ford' or the 'Tommy Steele'?

GEOFF: Both.

JOE: Well then your money helped set this place up.

We hear Mr Brolin banging dustbin lids and saying: 'Meek! Four o'clock this fucking morning I was woken up! How do you like a bit of racket?'

Let's hope you get some royalties from your little tune.

GEOFF: Well, that would be nice.

JOE: Be a love. Take this speaker and point it out the landing window into the back yards. These ones are sound proofed.

GEOFF carries a heavy speaker on a long lead off-stage down the stairs. JOE goes into the control room, turns a few knobs, picks up a microphone and yells:

Drop dead you silly old fucker!

We hear this heavily amplified out the back of the building.

Close the window and bring it back up. I have a really good feeling about this place. I know it is a little impratical, with the stairs and the traffic, but it has a very strong energy.

GEOFF: Yes. Yes I feel that too.

JOE: I'm sorry about Anton Hollywood Geoff. You could have been Reading's own Liberace.

GEOFF: That would have been nice.

JOE: But the real Liberace doesn't make little grunty noises when he plays does he. Shame. You are a wonderful musician, and a lovely looking boy.

JOE advances on GEOFF, who backs away into the piano causing a discord with his arse.

GEOFF: Bit of an old banger.

JOE: What?

GEOFF: The piano.

JOE: It was the only one we could fit up the stairs.

GEOFF: It sounds very strange.

JOE: Well, I've put drawing pins in the hammers. It adds an extra bit of sparkle.

GEOFF: Do you play any other instruments?

JOE: I don't play any instruments. I'm gifted enough in my writing and recording.

GEOFF: Really? Well it must make it very hard to compose.

JOE: No not really.

GEOFF: Can I ask…I don't mean to be rude. There's something I heard about you.

JOE: Yes. Go on I won't bite.

GEOFF: About…about you and Buddy Holly. About your prediction.

JOE: My predition. A message came to me. No words, just a date. Feb third. I warned him.

GEOFF: Febuary third. A day of great loss. Tragedy.

JOE: If only he'd listened.

GEOFF: Do you still try to communicate?

JOE: When I have the time. Next time you should join me.

There is a lot of noise from downstairs.

Here comes the Cavalry.

'The Outlaws' clumsily enter carrying their instruments. They are CLEM CATTINI, the drummer, a thick-set young man of twenty-one, he is no oil painting, but is very confident and down to earth, CHAS HODGES, the bass player, twenty-one, again average in appearance, but with a good sense of humour. They are both very cockney. And BILLY KUY, he is slightly older and very pessimistic and dowdy. They are all dressed in black cowboy outfits, complete with boots and Stetsons and are all wet from the rain outside, particularly BILLY.

CHAS: Fuck me. Those bastard stairs. Does my sodding back.

CLEM: You can shut your cake hole. You've only got to carry that you wimp. I've got the rest of the kit to bring up yet.

CHAS: It's not the kit that's the effort, it's having to lug that fat arse.

CLEM: You want to watch your mouth.

CHAS: You want to watch your diet.

CLEM: Yeah, you want to fuck right off.

BILLY: Ladies and gentlemen, Flanagan and Allen.
Oi, Joe it's pissing down.

JOE: Really.

BILLY: Anyone got a towel, I'm drenched. If I play like this I'm likely to get bloody electrocuted.

CHAS: Yeah, I'm gonna have a crap, I'll bring a towel back out with me.

JOE: Er, no you won't. You'll sit back down.

CHAS: What?

JOE: Well, I've got girls singing backing vocals there in fifteen minutes and it is vital for their singing that they are able to breathe in. You can do your business in the café across the street. You should've gone before you came.

CLEM: Who's got the arse now?

CHAS: Oh, fuck off. Look Joe you got to let me use the karsey.

JOE: *(Setting up the mikes for the amplifiers.)* Well Chas, it's just the other side of Holloway Road.

CLEM: In the rain.

CHAS: You'll be the one to suffer.

CLEM: You start letting rip in here and I'll find something to plug the hole with.

JOE: Geoffrey this is the band. What they lack in looks they make up for in charm.

BILLY: *(Coming back from the bathroom with a towel.)* Last time I got pissed on in this get up me nipples and armpits went all black.

CHAS: Shut up you soapy bollock.

BILLY: Took a week to get the stains off. Carbolic I had to use.

GEOFF: Why... Why don't you use an umbrella?

JOE: Because cowboys didn't have umbrellas.

BILLY: No, and I bet they didn't have black armpits either.

MAJOR BANKS enters from downstairs a little confused.

MAJOR: A small coup going on downstairs. Are we paying all these people? *(Clocking the cowboy outfits.)* Good God!

OUTLAWS: Hello, Sir. Watcha. Alright. *(Etc.)*

MAJOR: Take off those ridiculous cowboy suits.

JOE: Well actually, it's good publicity.

BILLY: Nothing good about getting your collar felt.

CLEM: No one felt your collar.

CHAS: They'd get all black fingers and that.

CLEM: Never been more embarrassed.

JOE: Well, at least we got everyone's attention.

MAJOR: I don't want a repeat of last week. Blasting the tune from a stage coach driving around, ordering your posse to hold up a record shop at gunpoint. I don't want to have to pay another fine for their stupid antics. Now get changed.

JOE: I don't see how a brush with the law can be bad press for a band called 'The Outlaws'. Can it Geoff?

GEOFF: I don't know what anyone's taking about or who anyone is.

MAJOR: Really Joe. Geoffrey this is Chas Hodges, Billy Kuy and Mr Clem Cattini. 'The Outlaws.'

JOE: This is Geoff. You're about to record his tune.

CHAS: Oh, it's your song. Lovely.

GEOFF: So you're not really cowboys.

BILLY: No.

CLEM: You want to watch him. He'd have you on top of a nineteen bus with your cock out the window if he thought it would shift a few records.

GEOFF: *(Panicking.)* Would he?!

*During this HEINZ BURT sidles into the room. He is
nineteen, with mousy hair, tall, lean, and quizzically very
attractive. He is quiffed and pressed but has not quite got away
with it. He is very energetic and positive, but his thinking is
slow. He is from Southampton, and so has a slightly overstated
cockney, mockney drawl. He laughs with the others, waiting
for his chance to get involved in the conversation.*

CLEM: I'm the one on a caution. We burst into HMV,
these two cowards fuck off, I'm left with me cap gun up
the counter girl's hooter, demanding a copy of our own
record, like the lone wanker.

BILLY: Guess what.

GEOFF: What?

BILLY: They'd never heard of us.

CHAS: Hark at Buffalo shape Bill. We all end up in the
back of a black Marria.

JOE: Marvellous press.

MAJOR: I had to play the blasted record to the desk
sergeant to prove their sanity. Those costumes are for
stage use only. Is that clear?

ALL: Yes sir.

JOE: Of course if there had've been any arrests we could
have staged a publicity break-out with...

HEINZ: Yeah, with dynamite.

JOE: And who are you young man?

HEINZ: I'm Heinz. I met Eddie Silver backstage at the
Palace Ballroom in Southampton. He said I should
come and see you like. You know, for an audition.
You know, said he'd have a word. You know put a

word in like. He said if I mentioned his name it'd be alright. He…he said I could come up on spec like. No appointment.

JOE: Did he. That's nice of him.

MRS SHENTON: Cooey. Joe. Joe. I know you're a bit… Oh, hello boys.

OUTLAWS: Hello, Mrs Shenton. Afternoon. *(Etc.)*

MRS SHENTON: Lovely shirts. Don't they look smart. Here you're all wet. You should've brought a brolly.

JOE / GEOFF: Cowboys didn't have brollies.

MRS SHENTON: Whatever. Look I know you're busy, but I've got a bone to pick with you. My stock room ceiling has gone all black and treacly. And Mr Brolin from round the back is downstairs in his dressing gown, he says you just swore at him.

JOE: Well he started it.

MRS SHENTON: Pardon?

JOE: I was just testing our new speakers.

MAJOR: Oh dear.

JOE: He yelled at me and I yelled back. I wouldn't repeat in front of these young boys the filthy language he was using.

MRS SHENTON: Oh, and that's what a recording studio's for is it? Give you a chance to play silly buggers and scare my neighbours. Well he is very upset. He works shifts.

CHAS: Yeah, and don't we all know about it.

JOE: If you can't take it don't dish it out.

MRS SHENTON: And what about my ceiling?

JOE: Well, that's why the ceiling is all black and treacly, because I had to poor a tin of liquid rubber down the floorboards *(Pause.)* for sound-proofing.

MRS SHENTON: Well it's no good Joe. It gave me ever such a stir. It's made a terrible mess. It's all runny and there's all flies sticking to it.

MAJOR: Violet dear, I am terribly sorry. We'll arrange for someone to pop down and rub the rubber off.

JOE: Well, it will have to be a bit later. We've got a major television star, John Leyton, coming round any minute, and as you can see I'm rushed off my feet.

MRS SHENTON: Ow, is that the young man off *Biggles*? Now I understand. *(To GEOFF.)* Sorry love I just thought you was a bit soft. I'd love to meet him.

JOE: Well you're going to have all the big stars passing through here now Violet. If you pop downstairs and make a pot of tea the Major can introduce you.

MRS SHENTON: Yes, and I'll tell him you're sorry.

JOE: Who?

MRS SHENTON: Mr Brolin.

JOE: Tell him I'm busy. Tell him what you like. Tell him to stick his bin lid up his big hairy…

MAJOR: A nice cup of tea! Splendid. After you Violet dear.

MRS SHENTON: Thank you.

They both leave.

JOE: You still there? So, where was it you said you were from?

HEINZ: Near Southampton.

JOE: And what is it that you do?

HEINZ: Bacon slicer.

JOE: Really. How useful.

HEINZ: Ow, you mean… Sorry. I thought… Oh, well, you know, sing. Play a bit of bass.

JOE: Alone?

HEINZ: No. No, the band are across the street in the café. We all come up on the train this morning.

JOE: Hmmm. Look, why don't you pop down the shop and get us a couple of jars of coffee.

HEINZ: Camp or Bird's?

Silence.

CLEM: Bird's.

CHAS: Bird's.

JOE: Looks like Bird's, and a couple of packs of Preulin. Here's a ten bob.

HEINZ: Right. What's that?

JOE: What?

HEINZ: That stuff what you just said?

JOE: Preulin. You get it at the chemists. Slimming tablets.

HEINZ: You on a diet?

JOE: No, I'm just going to be very busy. Pop back in an hour, we'll go upstairs and I'll see if I can fit you in.

HEINZ: Right. Great. Hour. Tar. Preulin. Right.

He goes. The phone rings in the control room.

JOE: Eager, isn't he.

GEOFF: Didn't notice.

JOE answers the phone.

JOE: Hello, RGM records. ...Hello Lionel... No, I'll be working late, and I don't think I'll be able to make it... Something's popped up. You too. I'll give you a call. Bye then.

Right, how are we doing boys?

CLEM: Nearly there.

JOE: Right. I've got to set the mikes downstairs, and I want to be ready to go when I get back.

He exits.

BILLY: He's barking.

CHAS: You playing that old Joanne?

GEOFF: Yes. Is it in tune?

BILLY: Doubt it.

GEOFF sees BILLY plugging into a strange looking black box, one of JOE's homemade echo units.

GEOFF: What does that do?

BILLY: Fuck sake don't touch that. He'll go barmy.

GEOFF: What is it?

CHAS: It's one of our Joe's little secrets, magic echo doo-dars.

BILLY: Fuckin loon.

CHAS: No, he's not mad, he's one of your eccentrics. What with his gadgets and his witchcraft.

BILLY: Load of bollocks.

GEOFF: He predicted the date of Buddy Holly's tragic death and warned him.

CLEM: Yeah. He's a proper Nostra-Fucking-Darmus.

GEOFF: February the third.

CHAS: Yeah? Right date, wrong year.

BILLY: Fuckin loon load of bollocks.

GEOFF: Well, it is easy to mock. There are many things that we do not understand. Not on this plane. My involvement in Spiritualism is quiet serious. I have been attending a weekly psychic circle for some months now in the hope of becoming a medium. In fact the song we are recording today came to me from the other side, from beyond.

BILLY: Fuckin hell.

There is a loud clap of thunder.

CHAS: Here, you're studying to be a medium, Clem's studying to be a large.

CLEM gives CHAS the 'V's.

BILLY: Someone's a large something.

JOE enters from downstairs.

JOE: Right, are we in tune and ready? We're running a bit late. John is downstairs being talked at by Mrs Shenton, I'm going to start sound checking, so a bit of noise from everyone for level. I want that *(Bass amp.)* moved over there, and no-one touch the fucking mikes.

BILLY: *(Cod RAF voices.)* Right, well you heard the man. Biggles is landing at 0500 hours.

CHAS: Chocs away, what what.

JOE: *(Puts his head round the door.)* And you can get that out of your system for a start because I'm having none of it.

CLEM: Roger, wing commander.

JOE: I fucking mean it!

JOE goes back to the control room.

CLEM: Sorry squire.

BILLY: Tone deaf actors, body builders, midgets. Fucking pantomime. What's next, a singing postman? Load of pony.

CLEM: Stop moaning you wet bastard. You're getting paid ain't you.

JOHN LEYTON enters. He is quite slight, about twenty-four, with all the breezy confidence and total ignorance of a television actor. He has a very faint camp manner, but is trying to act like a rock 'n' roller. He is wearing an RAF style flying jacket, over a pressed shirt, tie and trousers. His hair is side parted and slightly brushed back, and there is a slight air of fake tan about his complexion.

JOHN: Hi guys. John Leyton. You must be the band.

BILLY: Sharp as a pin.

JOE enters. He adopts a very relaxed air, contrary to the manner in which we have just seen him.

JOE: Arr. John. Lovely Jacket.

JOHN: Thanks, glad you like it. You know I've been wearing this thing so much lately I just don't feel dressed without it.

BILLY: Yeah, where did you leave your goggles?

JOHN: Right. Very funny.

JOE: This is Geoff. He wrote the song.

JOHN: Rockin tune.

GEOFF: Thank you.

BILLY: Where'd you park your plane?

JOHN: Same place you parked you horsey, partner.

CLEM and CHAS laugh. CLEM plays a diddle boom tat.

JOE: Quiet. Right, well, me and the boys have been rehearsing all afternoon. Where are those girls? Never mind, I can mix that in later, and now I want to go straight for a take for level. John you are over here.

JOHN: Yeah, cool. Oh, Joe, not my business, but those instruments I passed downstairs, the cello, and violins. I don't think you'll be able to hear them up here.

JOE: Thanks John, but we've got some microphones down there and that is what they do.

JOHN: Really. Great.

JOE: *(Shouting down the stairs.)* Charles tell your lot we're going straight for one for level. OK Clem count us in I'll be in my den and we'll see what it sounds like.

CLEM hits the sticks together on a count, as he does this the light quickly fades and we hear what was recorded that day. Very loud and brilliantly clear we hear the haunting epic ballad: 'Johnny Remember Me'.

Tableau

As the music fades out it is replaced by some bizarre futuristic sounds, and slowly the lights come up on the studio centre. There is a table dimly lit and two figures sit around it.

We start to make out JOE and GEOFF over the table in mid-seance. They have their fingers on a tumbler which is moving freely around the Ouija board that it is on. There are bizarre sounds, warps and clicks very echoed.

JOE: Buddy, will 'Johnny Remember Me' be a hit?

The glass moves at a steady pace around the board.

GEOFF: Number o-n-e. Number one.

The lights dim on them, and again the studio radio starts dimly to come to life.

DJ: For its second consecutive week at the top of the charts it's John Leyton, making that tricky transition from television star to pop star...

There is some more static. We hear a brief collage of news clips fromt the winter and spring of 1961. This ends with Helen Shapiro singing 'Walking Back to Happiness'. This fades and we again hear the strange sound effects of the seance. The sound fades, and we hear the terrible wailing of Joe's unrecognisable 'Telstar' demo. Lights up.

Scene 2

CLEM is in the studio behind his kit. He is joined by ALAN CADDY. He is a sheepish, slightly older polite young man, formerly of 'Johnny Kidd and the Pirates', and as such is from the old school. He is a little out of his depth.

JOE is in the control booth shouting out commands. Both the musicians have been there for some hours.

JOE: I don't want it on the ride, I want it on the hi-hat.

CLEM: I'm on the hi-hat.

JOE: Well play it closed.

CLEM: I've played it closed.

JOE: *(Head round the door.)* Then play it better.

CLEM: Oh, OK then.

JOE: Right well let's fucking get on with it then. *(Goes back to control room.)*

ALAN: How long have we got?

CLEM: Not fucking long enough.

ALAN: We never had this trouble with Johnny Kidd.

CLEM: I'll bet.

ALAN: Never recorded over a handbag shop.

CLEM: Yes, unusual ain't it?

ALAN: Always used to have to wear a suit to the studio.

CLEM: Riveting.

ALAN: It's that demo. I've never heard the like.

CLEM: Since Charlie Blackwell fucked off he's had no one to do the dots for him.

ALAN: So?

CLEM: So he can't play any instuments. He has to hum those fucking tapes.

ALAN: They're awful. He's tone deaf.

CLEM: We know. Look, I just want to get off, so play the chords, and with any luck he'll forget all about it.

JOE bursts in with an intense energy and starts moving mike stands.

JOE: Right. Clem it's like this: *(High pitched, slightly out of time with stomping.)* Doom te-te-Boom te-te-Boom.

CLEM: What's that then?

JOE starts to bash out time on the piano lid.

JOE: Listen. Boom te-te-Boom te-te-Boom te-te-Boom.

CLEM: Joe it's all over the shop. Is it four/four or two/four or what?

JOE: Just play it. Boom te-te-Boom. Now: *(Very high and off key.)* Twang twang twang.

ALAN: Pardon?

JOE: Twang, twang, twang.

CLEM: Listen mate we got to be in Great Yarmouth by six. By rights we should be leaving in an hour.

JOE: *(To ALAN.)* That's it. Do that. *(To CLEM.)* And you, just play what you always bloody play. *(He starts to hum along out-of-tune.)* Not bad. Stop, right. Now I want eight bars of that. Twice. *(Humming off-key he goes to the control room.)*

CLEM: What did you do that for?

ALAN: Sorry. Sounds alright though.

JOE: *(Pause.)* Well fucking get on with it then.

ALAN: Sorry mate. No cue lights.

CLEM: Two-three-four.

They play the bars for a few seconds.

JOE: *(Enters studio.)* Hold it, hold it. Clem what are you doing?

CLEM: Drumming.

JOE: What's that daft beat on the kick drum?

CLEM: I don't play daft beats on the kick drum.

JOE: I don't have time to argue. Go again.

They play again. JOE comes in again after a few bars.

Oh, for fuck sake what are you playing at?

CLEM: I'm not playing at nothing.

JOE: Boom tat, Boom tat.

34

CLEM: Don't start that up again.

JOE: Play it.

ALAN starts to play the riff. CLEM stands up.

CLEM: I know what I'm playing chief. You've gone mad.

JOE: Shut up.

We hear a low booming noise, a broom hitting the ceiling, followed by the muffed cries of MRS SHENTON. JOE goes to the stairs and shouts down.

Shut up you old bag. Carry on then.

MRS SHENTON: *(Voice off.)* I want a word.

JOE: Give me strength. I'm recording.

MRS SHENTON: *(Voice off.)* Sorry Joe, it's important.

JOE: That bloody woman. Right keep practising. I'll be back in a minute.

CLEM: Joe we don't have time.

JOE: Well I'm your manager. And I say we do.

CLEM: I don't want us to be late, Larry gets all touchy.

JOE: Fuck Larry Parnes, fuck Billy Fury, it's my tour, The Tornados are my band and you'll stay sat there till you finished the session.

He leaves for downstairs.

CLEM: Fucking hypocrite. He only put The Tornados together to get in with Larry Parnes.

ALAN: We never had any of this in The Pirates.

CLEM: Course you didn't. Cause Johnny Kidd didn't have a different manager than the pirates did he. Cliff Richard doesn't have a different manager than the

Shadows.

ALAN: No, I s'pose not.

CLEM: But Billy Fury and The Tornados are on tour with two managers. Joe put a backing band together to lure Fury in here but Larry Parnes won't let Joe speak to Fury. Got him wrapped up in brown paper. Joe's got as much chance of getting Billy Fury singing in his toilet as we have of getting to Yarmouth by last orders.

ALAN: Well, let's get on with it then. *(He starts to play.)*

CLEM: Nah, fuck that.

HEINZ enters from upstairs where he now lives. His hair is a shocking peroxide blonde, he is wearing a dazzling silver thread drape suit and has a copy of The Eagle *comic under his arm.*

HEINZ: Hello boys, how's the noise.

CLEM: Alright?

ALAN: Hello mate.

HEINZ: Are we off soon?

CLEM: Allegedly.

HEINZ: What?

CLEM: About an hour.

ALAN: We hope.

HEINZ: You been down here all day?

CLEM: Yep.

ALAN: Since quite early this morning.

HEINZ: Do you think he'll want me to do the bass again?

CLEM: Not in the next half hour.

HEINZ: No. No I s'pose not. If he did he would've just popped upstairs for us. Mind I've done it once.

ALAN: Yeah.

HEINZ: I only had to play it the once.

CLEM: Such talent. I played it once, at nine o'clock this fucking morning. I've played it a few times since.

HEINZ: Oh, right. It must sound good then.

CLEM: To be honest mate, I couldn't tell you and I couldn't give a monkey's.

HEINZ: What do you think of the whistle then?

ALAN: Very smart.

HEINZ: Pucker ain't it. He just left it upstairs, in me room.

CLEM: You look charming.

HEINZ: Cheers.

CLEM: Don't know about the tie though.

HEINZ: What about it?

CLEM: It's alright, it's just a bit, you know… Ain't it Alan?

ALAN: What?

CLEM: The tie.

ALAN: Oh, yeah.

HEINZ: What's wrong with it?

CLEM: Nothing mate. It's fine.

HEINZ: No you're right. It is a bit. I'll just pop up and change it.

CLEM: Suit yourself. *(He plays a didley boom tat, on the kit.)*

HEINZ: About half an hour then.

ALAN: Yes matey. Something like that.

HEINZ: Handy living upstairs. *(HEINZ leaves for upstairs.)*

CLEM: Too fucking handy. Soppy as a box of frogs that one. I wouldn't mind if he could play.

ALAN: He's alright.

CLEM: Bollocks. Chas can play. We had some laughs on the Johnny Leyton tour.

ALAN: He not singing anymore? Leyton?

CLEM: No. We appear to have lost him to his acting career.

ALAN: Isn't he in that new POW film with Dickie Attenborough?

CLEM: Yes, he's Willie the Tunnel King.

ALAN: Didn't he use to be Ginger?

CLEM: From the sound of things he still is. Fucking ponce.

ALAN: Who?

CLEM: 'Pop up and change it.' I haven't been home since Wednesday. Can't remember the last time I changed me pants.

JOE and MAJOR BANKS enter from downstairs. They are in the middle of a disagreement. They are closely followed by PATRICK PINK. He is a dark very pretty young man of twenty. He is smartly dressed, but not of any extreme fashion. He has a very polite manner. He is the sort of boy any mother would be very proud of. He is carrying a heavy stack of two-inch reel tapes.

JOE: Blood out of a stone. Patrick, take them downstairs and put the kettle on.

MAJOR: Those tapes are expensive. They're not to be trifled with.

JOE: I am not to be trifled with. Begging for tapes is not what number one record producers should have to do.

MAJOR: It will take some time for the revenue from those hits to actually appear.

JOE: Oh, and what do I do in the mean time, play conkers with the boys?

MAJOR: Of course not.

JOE: Of course not. I record. I record so as we can have more hits. Can't do anything without tapes.

MAJOR: Joe I want to expand, but let's not try to run before we can walk… A step at a time. Steady growth. You have Patrick now as a full time office assistant.

JOE: Well, woopy-fucking-do Mr Rockerfella.

PATRICK puts his head around the door.

PATRICK: Joe, sorry Major sir, Joe, phone.

JOE: Yes well we're already running Major, we've had a number one. Who is it?

PATRICK: It's Brian Epstein.

JOE: Oh shit.

PATRICK: Wants to know what you thought of the demos he sent you.

JOE: Oh yes. He's got some Mersey beat combo. They're rubbish. I'll be back in five minutes. *(To MAJOR.)* And you don't go in there. *(Points to control room.)* And you bastards get practising. *(He leaves for downstairs.)*

CLEM: Major, could you have a word? We've got to be in Great Yarmouth by six. He'll have us sat here all day.

MAJOR: That is up to Joe.

CLEM: I haven't seen daylight for two days.

MAJOR: Well believe me it's not changed much.

CLEM: I'm sure. But he's been driving us up the fucking wall. Ain't he Alan?

ALAN: Yes. Rather strange behaviour.

CLEM: You heard what happened to Billy Kuy. All he did was come round and ask for his money, which I may add no one has seen yet.

MAJOR: Greedy little bastards, no one receives royalties. You're all on session fees, seven pounds, six shillings.

CLEM: Does that include being attacked with a pair of scissors and being pushed down the stairs, fucking terrifying, could've killed him.

ALAN: Oh Christ.

CLEM: How do you think Alan feels? He's Billy's replacement. Fuck knows what he might do to him.

ALAN: Oh, cheers.

CLEM: No mate, what I mean is, he could go berserk at any of us. Well, except for fucking blond rinse upstairs. Which is another thing, he's living rent free upstairs, treated like Presley, and fucking clueless. Plays bass like he's wearing boxing gloves.

MAJOR: Have you quite finished?

CLEM: Yeah.

MAJOR: Firstly, Billy Kuy has been given compensation much against my better judgement – I'd have thrown him out of the window. Joe is also your recording manager and as such has complete control over who plays with who, and I think you Clem can afford yourself a little faith in his judgement.

CLEM: Fuck sake.

MAJOR: I've not finished. We may have had an incredible first year, but Joe is desperate for a big hit, not just for him, but for all of us, and while you are in the pub, or playing darts, or doing whatever it is that you types do, Joe is working. Constantly, boy's a genius. So if you're feelings are hurt, or your opinions ignored as a result of these tensions, I feel it is of a very small consequence. Do I make myself clear?

CLEM: Yes.

MAJOR: Good.

JOE returns from downstairs.

JOE: Poor Brian. He's a sweet man, but he doesn't have a clue what the kids want. Now listen. I'm having interruptions from Violet, she's picking the guitar amp up on her wireless, she can't hear 'The Navy Lark'.

MAJOR: Well, I'll chat to her on my way down. Leave you to it. Just thought I'd pop in.

JOE: And spy.

MAJOR: Just curious to see where the tapes were going.

JOE: Well, suprise surprise, I'm recording with them.

MAJOR: Of course. Good-bye.

PATRICK: Joe?

JOE: Patrick, phone Geoff and tell him to get in a cab.

PATRICK: Coffee?

JOE: Coffee.

PATRICK leaves for downstairs.

Right you buggers, let's hear it.

CLEM: Hear what?

ALAN: We had a little break, but we were practising, weren't we.

JOE: For fuck sake, Twang, twang twang, Boom tat Boom tat.

They play.

Yeah, that's it. Now keep it going.

JOE goes into the control room and adds some echo to the guitar. It sounds amazing.

Right, stop.

ALAN: What on earth was that?

JOE: One of my magic tricks. Now then what I want is that twice, a break of eight bars, and I mean silence for eight, then that again, and then I'll mix them onto what you've done already as the breaks.

CLEM: Goodie.

JOE: What was that?

CLEM: Nothing.

JOE: Don't try my patience. Right, in your own time.

ALAN: Count us in.

JOE goes to the control room, CLEM counts them in. They play the first riff. The sound is brilliant. During the silent break of eight HEINZ comes down the stairs, smiles at the boys, and waves, they gesture for him to go away. He looks miffed, goes to knock on the control room door, the other two again try to mime to him not to knock, he looks a little angry at them and knocks loudly on the door.

JOE: What now! Fuck off, I'm busy!

HEINZ knocks again loudly, JOE opens the door, he is ready to bite someone's head off but stops in his tracks when he sees who it is.

HEINZ: Hello Joe, how's the show?

JOE: Sorry, thought it was some other bastard. – Right stop.

HEINZ: Thanks for the whistle.

JOE: Hmmm.

HEINZ: Well what do you think?

JOE: What do you think?

HEINZ: Oh, yeah. I love it. Pucker. Pleased as punch. Thanks.

JOE: Well I love it. You look terrific. Come into my inner sanctum.

HEINZ: Whooooooo.

JOE: Right, sounds great boys. Pop down and have a fag. Just the one.

CLEM: Tar.

ALAN: Thank you.

JOE closes the control room door. As CLEM and ALAN light up, the lights dim on them leaving silhouettes and burning cherries leaving the studio, and rise on JOE and HEINZ in the small cluttered control room.

JOE: You really do look smashing. I love the tie. It's a lovely touch. Bit of sparkle.

HEINZ: Yeah?

JOE: You are an individual Heinz. Bit special. You don't know it yet, but you have a little bit of sparkle in you.

HEINZ: Nah, don't be silly.

JOE: You see, you can't see it but I can. You have a special something. Sit down, I want to tell you a story. Well, when I was a boy back in Gloustershire I had a terrible accident with some phosphorous. You see some had been left by our local home guard, and I was an inquisitive child and so I discovered that if you put a little of this phosphorus on your hands and clapped there was a small explosion. Of course I thought that I had discovered something wonderful, so I started putting more on my hands and clapping harder until I put a small lump in my palm and clapped hard. Well of course there was a tremendous explosion, which knocked me off my little feet, and when I got up I found that my hands were terribly burnt, and the phosphorus was still burning and kept burning all the way home, until my father who was a veteran of the first war, put my hands in a bowl of milk but of course by now my little hands were burnt to the bone. So we rushed to the hospital, but the specialist said that I would never be able to move my hands again.

HEINZ: Nah, nothing wrong with your hands.

JOE: Yes, that's because there was one doctor, very special man. He saw a ray of hope for this little boy. And so every day two times a day, for two hours a time, he would carefully change the dressing and bandages, and so slowly they started to heal and after a long long time they got better.

HEINZ: Yeah, they're bloody clever these doctors.

JOE: They work miracles. You see this young man saw there was a spark of hope. He made a commitment to me because of that little spark. And I made a commitment to him. *(JOE takes HEINZ's hands and locks him eye to eye.)* These aren't the hands of a bass player.

There is a knock at the door.

What?

PATRICK enters.

PATRICK: Your coffee Joe.

JOE: Oh, thanks.

PATRICK: Geoff is on his way, and the boys downstairs are getting restless.

JOE: Doesn't he look stunning?

PATRICK: Very smart.

JOE: Right, now upstairs and pack. I don't want you wearing that on the bus.

HEINZ: Yes mum.

JOE: Get out of it.

HEINZ giggles and leaves.

HEINZ: 'We're gonna have some fun tonight, woo…'

JOE: *(Takes coffee.)* Thanks. Any sweets? I am going to finish this track if it kills me.

PATRICK: You should get some sleep.

JOE gives him a stern look.

Blues, mother's little helpers?

JOE: Fine. *(JOE takes a small bottle from PATRICK.)* Just take it out of petty cash.

PATRICK: I did.

JOE: I know. I can trust you Patrick.

PATRICK leaves for downstairs, JOE takes a handful of bombers from the bottle and necks them with several gulps of

black coffee. He bursts into the studio, the lights burst up, he shouts down the stairs.

Right, now tell those two bastards to get back up here.

JOE goes into the control room and starts playing a collection of bizarre and brilliant sound effects that he has been recording that will be the introduction to the record. We recognise them as the sounds from the earlier seance scene.

Fucking hurry.

He is manic and wired. CLEM and ALAN enter the room more than a little confused. They quickly get behind their instruments and start to play.

Right. Boom. *(Banging on piano.)* Boom, boom. Boom, boom. Strum, strum twang, twang.

ALAN: Where from?

JOE: Just play it, Boom boom, twang twang.

CLEM: What the fuck's got into you?

JOE: *(Smiling.)* It's the Intro.

CLEM: It's bollocks.

JOE: What's that?

CLEM: It's a load of silly noises. What are you playing at?

JOE: I'm not playing at anything, and neither are you, now get behind that kit and do what I say. *(They play.)* That's it. Up, up, up, up. Right, I've got a clean tape running so keep it going till I say stop.

JOE runs into the control room, the two play for about half a minute. JOE yells ecstatically from inside the room.

That's it. LIFT OFF.

CLEM: Right, that's it. Stop. Alan. Stop.

ALAN: Erm…are you sure?

CLEM: Now.

JOE bursts back out.

JOE: What's happened. Why aren't you playing?

CLEM: Because we're going to Yarmouth.

JOE: What?

CLEM: We don't have a clue what you're on about, Joe!

JOE: What!

CLEM: And I'm not letting the whole band cop it, cause you've some silly bollocks idea that sounds like a bee starting a car in a cave.

JOE: Fucking sit down!

ALAN: He does have a…

JOE: You shut the fuck up!

ALAN: Yes, of course. Sorry.

JOE: But I've already phoned Geoff to come in and play the keyboard.

CLEM: Geoff, that daft bastard.

JOE: How dare you.

CLEM: All that song from beyond the grave bollocks. It's embarrassing.

JOE: Well it's true.

CLEM: I'll tell you what is true. I am truly MU dep for this band, I am truly calling this recording session to an end.

JOE: What…!

CLEM: Sorry Joe. I don't normally do this. *(Shouts upstairs.)* Oi, gormless, we're going.

HEINZ: *(From upstairs.)* What? Oh, yeah, coming.

JOE: You fat bitch! You pair of cunts! Fucking get out! OUT! You... You Communist Cunt!

ALAN: Sorry... Of course strickly speaking I'm not an MU...

JOE: Fuck off out of it, and don't ever come back. You ungrateful pair of cunts! *(HEINZ passes him.)* Have you got your suit?

HEINZ: Yeah, great. Listen about that thing earlier. The commitment. Definitely yeah.

JOE: Take an umbrella. It's raining, you must watch your hair.

HEINZ: Yeah. Don't want to go all fluffy. Right well. Bye guy, gotta fly.

JOE is left alone with the sound effects playing. After a moment he goes back to the control room and plays what he has recorded so far. Drums bass and guitar, he turns it up loud, and returning to the studio room starts to hum along, high pitched, slightly off key and out of time, but with a lot of passion.

GEOFF enters after a minute. JOE does not see him, as he is carried away with his own invention.

GEOFF: It's raining. *(Louder.)* It's raining.

JOE: Hello.

GEOFF: It's raining. There's a storm like last year. Good omen.

JOE: Listen.

GEOFF: It's great. What is it? What are we doing?

JOE runs to the control room and turns the music down and runs back. He is slightly out of breath, but it seems to have done him good. He is still hyper but much less angry than before.

It sound incredible. What is it? What are we recording?

JOE: Those ungrateful Tornados bastards.

GEOFF: Good. What are we doing?

JOE: I'm working on an instrumental for them, so they can have a solo slot before Billy Fury comes on to join them. Sort of like their own 'Apache'.

GEOFF: Doesn't sound very Red Indian.

JOE: Those ungrateful bastards have gone to Yarmouth and I need the keyboard doin.

GEOFF: What's the track called?

JOE: 'The Theme Of Telstar'.

GEOFF: Good. What's that then, Telstar? I heard of that.

JOE: It's a satellite. A miracle of science, it orbits the planet nine times a day.

GEOFF: Amazing. Why?

JOE: Well, it picks up invisible rays and beams them back to earth.

GEOFF: Why?

JOE: So we can communicate with the other side of the world! You can talk to anybody anywhere, just imagine it.

GEOFF: Like the ether.

JOE: Yes, yes it is a bit like the ether, but it's science.

JOE goes into the control room and at a much more reasonable volume plays the tape. And hums along.

Listen we lift off. De, de, de, de, de de. No. No not on the piano. On this.

GEOFF: What. What am I playing?

JOE: *(Points.)* This. It's an electric keyboard. It's monophonic.

GEOFF: Oh, very si-fi. (*He plays. By current standards it sounds comically flat and dull.*) It sounds very odd. I like it though. It's… It's aloof. I like that word. Aloof.

JOE: Right Dee, de Dee de, Dee, de, dee, de, de, dee… Do you want to hear the demo?

GEOFF: We could do. No, we're doing fine.

JOE: That's it.

GEOFF: De do, De do, Dee, do do, do, do doo.

JOE: Then it's up to space, doo de do do de ded do dum. Then we hover. Do De do dee do do de dum, and we look down at earth, at humans… Do de Do Dee doo… Right at the crescendo everybody's talking, everybody's communicating.

GEOFF: Hold on. Yes got it.

JOE: Yes, doom de de do doom

GEOFF: How about… *(Playing and singing.)* Do Do Do do dum do do de de dum.

JOE: Oh, yes, I like that…

GEOFF: Almost got it.

JOE: Gonna run a bit of tape.

As he goes into the control room the lights dip and we hear the sound effect at the start of and the full glory of what became…

'Telstar' by The Tornados. The biggest selling record of all time.

Blackout.

About a third of the way through the tune, the music starts to soften and we hear the radio burst to life, and we hear the repeated last refrain through the radio speaker mixed in with a montage of news and static.

DJ: With a record breaking eighth week at the top it's the Tornados *(Static.)* …It gives me great pleasure to present this second Gold Disc to the song's producer and writer Joe Meek. The Tornados have become the first British act to 'top the charts' in America, making their hit 'Telstar' the biggest selling record of all time.

The radio starts to play 'How Do You Do It' by Gerry and the Pacemakers, and the lights come up. The studio is being refurbished, new equipment is installed and Gold Discs are being hung up. MRS SHENTON and JOE are sharing a cup of tea on the landing outside the bedroom.

MRS SHENTON: I've shown that man from the papers in to the studio, I hope you don't mind. Well I s'pose you'll be moving out now. Onwards and upwards. Though God only knows how I'm going to let this place.

JOE: No, I don't think I'll be going anywhere just yet. Truth is I've never really felt that I fitted in anywhere and well what with you and Albert and your kindness I feel I've built a little home.

MRS SHENTON: Well that's nice. Oh and Gordon said to thank you for those concert tickets. Him and his friends had a lovely time. He particularly liked the rolling boys. Are you going to make a record for them?

JOE: Rolling Stones… No. No I don't think so. They're just a little warm-up act. Anyway mustn't keep the press waiting. I'll pop down later.

He goes downstairs.

Hello Mr?

PEEL: Peel. *New Musical Express.* We spoke on the phone.

JOE: Of course. As you can see, it's all go. I'm afraid I can only give you a few minutes.

PEEL: OK then. Let's begin. An easy question. Who are your favourite artists?

JOE: Judy Garland. Les Paul and Mary Ford, and modern jazz. I shall be recording jazz soon.

PEEL: None of the new Merseybeat scene?

JOE: I really don't understand all the fuss about the Liverpool scene. Cliff Bennett and Rebel Rouser have been doing exactly the same thing, and so has Joe Brown.

PEEL: Very talented couple of names. Which other artist do you supervise?

JOE: The newest one is Heinz. H-E-I-N-Z, Peel like the beans.

PEEL: That's very funny. Another one of your colourful stage names?

JOE: It's his real name actually. He's half German. Heinz Burt as in Lancaster. He is very talented and has the looks that I believe the public will find very appealing. Mark my words. He will be the biggest star in the pop world within a year, bigger than that drunken has-been streak of piss Billy Fucking Fury!

PEEL: One to watch then. Telstar must have made a big difference to your finances. How will it effect you, both professionally and personally?

JOE: It can take a long time for the writer's royalties to appear. I won't be moving studio yet, but I don't have to watch the pennies.

PEEL: And what about the possibility of becoming the first

pop music recipient of an Ivor Novello Award?

JOE: I know. Well that's shown a fair few bastards ant it? Even if I don't win.

PEEL: I'll just put that 'Telstar' has received enough recognition just by its nomination. And finally. What do you say to those people who attack 'Telstar' as being banal?

JOE: It's sold three million.

PATRICK leans in the door.

PATRICK: Joe, sorry to interrupt again, the car's outside to take you to the Palladium.

JOE: I'm afraid that's all the time we have Mr Peel, mustn't keep Her Majesty waiting.

JOE starts to walk PEEL towards the door.

PEEL: Of course not. I've plenty here. Thank you. So, what is your future Joe? What can we all look forward to?

JOE: I want to go into film scores, I love the cinema. I want to write a musical. Opera, classical, I'll be recording jazz soon. I want to go on to bigger and better things.

Blackout.

Scene 3

Lights up. LORD SUTCH sings 'Jack the Ripper'.

SUTCH: Alright was it? Wasn't a bit hoarse...me throat...?

JOE: No, it was lovely. Good laughter. Now, I'll do an introduction with footsteps and some women screaming, like they're being murdered.

SUTCH: With loads of echo.

JOE: Oh, of course, the full 'Joe Meek sound'. Now, I want to have a chat about publicity.

SUTCH: Yes the stunts get better and better.

JOE: Well you're so versatile, you made a brilliant Viking.

SUTCH: Yes, but a Viking in a supermarket.

JOE: Shoppers you see. Terrible gossips. That's your best word of mouth.

PATRICK: Yes, made all the local press.

SUTCH: Well, I've had a few ideas myself. What about Piccadilly Circus?

JOE: I don't think you should do the Viking thing twice.

SUTCH: No, not the Viking thing…sheep!

JOE: Sheep?

SUTCH: I've always fancied herding sheep.

JOE: Well, have you ever herded sheep? I have. My brothers do it back home. Very unruly. Especially without a dog.

SUTCH: I'll be dressed up, you know. I've got this crook.

JOE: What if one of the flock were to stray and get run over?

SUTCH: Hmmmm. Yes, I suppose so.

JOE: Good idea though. Perhaps we can look into it a bit more. No, I've got a much simpler idea…we should paint arrows on all the roads and buildings around Oxford Circus, all leading to the shop where the record is for sale, and Sutch will be performing.

SUTCH: A bit low key.

JOE: It's not low key, it's subtle. I've been studying psychology, and people follow arrows. They can't help it.

PATRICK: Who's going to paint them?

JOE: Oh, we'll just get a bunch of kids, orphans or something... Like in *Oliver Twist.*

SUTCH: How about if I just drive round Whitechapel in the hearse, in the ripper clobber, jumping out at women shoppers. You know, with a big knife and loads of fake blood.

JOE: Brilliant. Simple. Brilliant.

SUTCH: And I could get the stuffed crocodile strapped to the roof of the car.

PATRICK: Jack the Ripper didn't have a crocodile.

SUTCH: I know, but it don't half get you noticed.

JOE: Patrick, get on the phone. Tell that press agent to start pressing people. I want it so as all the world and their wife sees Sutch stabbing these ladies.

PATRICK: Right away boss.

SUTCH: This is gonna be alright with the good taste and decency lot ain't it? I mean, they are gonna press the record ain't they?

JOE: Oh, if Harold MacMillan himself doesn't like it he can fuck off. I've made the biggest selling record this country's ever had. Patrick?

PATRICK: Geoff is coming in a few minutes. He says he's got some ideas.

JOE: Has he now.

HEINZ comes downstairs.

Well look, Sutch, Patrick will take you down to say hello to Geoff, then give yourself an hour. If that's OK.

SUTCH: I like Geoff. He's a fucking nutter. Yeah. Joe, have a think about them sheep.

They exit. HEINZ looks around the bathroom.

HEINZ: Joe. Alright if I borrow your aftershave? For tomorrow morning, I left mine in Aylesbury.

JOE: Of course. How was it?

HEINZ: Not as nice as yours. You know, Old Spice.

JOE: No silly. The gig.

HEINZ: Oh yeah, sorry. Oh yeah, good. Good gig.

JOE: Glad to hear it. Sorry I couldn't go. Still, can't be in two places at once. Listen, Mother's invited you up home. You got a date in Gloucester later on the tour. Thought we could make a long weekend out of it.

HEINZ: Yeah.

JOE: You know, get a bit of the country in us.

HEINZ: Yeah. Sounds great.

JOE: So the other dates go alright? I missed a couple, Cardiff?

HEINZ: Yeah Cardiff.

JOE: Bristol?

HEINZ: Bristol. Yeah a good gig. Well you can't fail. Gene Vincent and Jerry Lee. They are the greatest.

JOE: No, Buddy was the greatest.

HEINZ: But when Jerry does 'Great Balls of Fire'.

JOE: Great performer.

HEINZ: And when Gene does 'Be-Bop-a-Lula'.

JOE: That's who you want to watch. Do what he does.

HEINZ: Yeah, but it's different for him. For them.

JOE: How?

HEINZ: Well it's like. Well the Teds, they come to see
Vincent and Jerry Lee, and they're hard you know.
Rough. Rough lot.

JOE: Well, you have to win them over.

HEINZ: I can't. I don't know how. I get jeered as soon as I
step on the stage.

JOE: What do you mean, 'jeered'?

HEINZ: They call me a poof and that. Shouting up that
I'm queer, cos of me hair, and the suits.

JOE: After the songs?

HEINZ: Yeah. It gets worse then. Aylesbury some herbert
got on stage and chucked beer all down me suit.

JOE: Oh God.

HEINZ: Worst was Southampton. I done that thing that
you said about looking at a nice girl in the crowd for
'Dream Come True', and it was like the bloke's bird
and they all decided to get us at the stage door, mum
overheard them, it was only her tip off like, what saved
me. She was more scared that I was.

JOE: Oh, poor love, she would be.

HEINZ: I mean, Vincent does that look at girls trick every
night when he does Be-Bop, and it goes down magic.
Sometimes I look at them two stars, and I can't believe
that I'm playing with them, and other times, I wish
didn't have to.

JOE: What do the rest of the boys do?

HEINZ: Vincent's alright. He bought us a beer.

JOE: No, I mean our boys. The band.

HEINZ: I'm not one to grass.

JOE: No, of course not. I asked.

HEINZ: Yeah, well since you asked, Chas gets right on my wick, cos he like, joins in.

JOE: He what?

HEINZ: He, like, calls me the light bulb. Cos of me hair and that.'

JOE: He fucking does what?

HEINZ: Yeah, he goes up to the mikes, and points at me hair, and says, 'Put that light out.'

JOE: Light bulb indeed.

HEINZ: They just don't like me Joe. I mean what if... maybe they just don't like me.

JOE: Confidence, that's all it takes, you're on tour with two rock and roll greats cos you're talented. I'm not wrong about this. Now, I was going to save this for a surprise, but just to help your confidence I'll tell you now. I've been talking with some people and I've got at least two and maybe three TV slots lined up for you when the disc is released.

HEINZ: You're joking!

JOE: I'm not.

HEINZ: I'm gonna be on telly. What?

JOE: Well, the *6:5 Special* for a start.

HEINZ: Bloody Nora! *(Goes to the door.)*

JOE: Confidence. That's all it takes. I'm confident in you. You've got lots of talent. *(From control room.)* Now let's have a look shall we? *(Plays 'Dream' from control room, puts mike stand in middle of room.)*

'I've been told.'

Lean in, like Gene Vincent.

'…and I know it's true.'

Hips. Swing your hips. Look out, over their heads.

'…when you love dreams do come true.'

Click your fingers.

'…I believe, that out of the blue…'

Head. Keep bobbing your head. Like Buddy.

'Someone will come along and make my dreams come true…'

Finger, finger.

'I drift on clouds, way up…'

Hips, hips. Now wait.

'Up above the roof-tops…'

Now shake it up…

HEINZ does a bizarre dance around the room.

Straight back in. Fingers and hips. Finale…finale. Look out. Head up. Up.

That was breath taking. You keep that up, forget Gene and Jerry, you'll be bigger than Presley.

HEINZ: Nah.

JOE: You watch those two and learn, cos after your record is released, it will be you on the top of the bill, and you

better get ready for it. And I'm working on a big hit for you. You're own little Telstar.

HEINZ: I'm sorry Joe.

JOE goes to studio door.

JOE: What for?

HEINZ: For whinging. I should be...

JOE opens door and yells.

JOE: Patrick.

PATRICK: Boss?

JOE: Cancel everything for tonight.

HEINZ: ...should be more confident.

JOE: I'm coming to tonight's show, and you can put that bag back cos from now on I'm having Lionel pick you up and drop you home from every gig no matter how far.

HEINZ: But...

JOE: You are a star. You're going to be a big star.

JOE holds HEINZ's face in his hands.

You are my Golden Boy.

They are frozen for a moment, JOE leans to kiss HEINZ, HEINZ does not flinch. GEOFF bursts in. He is oblivious to the situation. HEINZ ducks his head, grabs his bag and runs upstairs.

GEOFF: Sutch is such a interesting man. He is very dark, very strong...mysterious. He's gone to the pub now. Anyway. There's a lad, Tom, downstairs. I think you'll like him. He has a very distinctive voice, and he is very striking.

JOE: Don't you fucking knock!

GEOFF: *(Pause.)* Sorry.

JOE: I was right in the middle of sorting something out.

GEOFF: Sorry. So, shall I send him up?

JOE: Who?

GEOFF: Tom, the lad from Wales that I told you about.

JOE: No, send him home. I'm busy.

GEOFF: But Joe, he came all this way.

JOE goes into control room and changes tapes.

JOE: I'm running a business, not a charity, and not a fucking dating agency.

GEOFF: I didn't think it would upset you.

JOE: It hasn't upset me, I'm just busy.

GEOFF: I suppose I could've brought him to the seance this evening.

JOE: Tonight. Sorry Geoff. I'm off to Wolverhampton for Heinz's gig, and Lionel, he's driving us.

GEOFF: Oh.

JOE: Talking of Heinz, where's his big hit? How's it coming on?

GEOFF: I've got some ideas. I thought perhaps another tribute song. Not Buddy Holly this time but Eddie Cochrane.

JOE: Maybe. When can we hear it?

GEOFF: I've not started it yet, but I've got you something.

JOE: What Geoff, we're s'pose to be working.

GEOFF: It's our anniversary.

JOE: Pardon.

GEOFF: We've been writing together for eighteen months. *(Hands JOE a box.)* It was yesterday I realised. I thought I'd surprise you with it this evening.

JOE opens box to find a watch.

JOE: It's not engraved.

JOE drops the watch in the bin. PATRICK enters.

PATRICK: Joe, The Outlaws are downstairs.

JOE: Heinz will be driving down with me and Lionel later.

PATRICK: I'm sorry Joe. The Major is with them. He says he wants to address everybody. He's got a right strop on, but if you want I'll tell him…

JOE: No. It's fine Patrick. Go upstairs and fetch Heinz down. I'm sorry about the watch Geoff, I'm just a bit tense. Now do me a favour and send the rabble up on your way out. Oh, Geoff, I hope the seance helps you finish that song. We need a hit.

GEOFF leaves. JOE takes watch out of the bin and then drops it back in again.

CLEM, CHAS, MAJOR, RICHIE BLACKMORE, HEINZ and PATRICK all enter.

MAJOR: Line up you horrible lot, quickly. Could any of you furnish me with an explanation as to why our new tour bus looks like it's been through the Battle of the Somme and is covered in flour and eggs?

CHAS: It got battered.

MAJOR: Very droll Hodges. Well.

CLEM: There was this nutter chasing after us in Swindon.

RICHIE: Chippenham.

CLEM: Chippenham, chucking house bricks at us from out of his car.

MAJOR: Unprovoked?

CLEM: Totally.

CHAS: Maybe he was a Shadows fan.

MAJOR: Really? Because I have in my hand a piece of paper. Unlike Mr Chamberlain's this is a summons to appear at Chippenham Magistrates court.

CHAS: Do we get top billing?

MAJOR: We could all do without your vulgar music hall comments Hodges. We are charged with breach of the peace, and driving without insurance. A dreadful clerical mistake perhaps?

HEINZ: It was his idea. *(Points to CHAS.)*

CHAS: You dirty fucking snitch.

CLEM: It was his idea.

CHAS: Oi!

CLEM: But we all, *(To HEINZ.)* all joined in.

CHAS: Soppy bollocks gets me with an egg in the face when I come out the karsey at some farmhouse, then he gets in his car and speeds off. So,

CLEM: So we all bought a tray of eggs…

CHAS: …and some bags of flour…

CLEM: …and flour, and pelted the car from the van on the A40.

CHAS: …I mean you don't half get bored in the back of the van.

MAJOR: A book would perhaps be less disruptive.

RICHIE: Rude, though.

MAJOR: I'm sorry?

RICHIE: Yer know. Sat there in a van, reading. It's like yer ignoring all yer mates.

MAJOR: A unique sociological observation, but rather a feeble excuse Mr Blackmore.

CHAS: Then we started getting bods in the street. Friendly like.

MAJOR: I see, and one of these 'bods' in an equally friendly manner returned fire with house bricks?

CLEM: That's about the size of it.

MAJOR: And whose idea was it to attack members of the public?

RICHIE: Vincent.

MAJOR: Gene Vincent? And I suppose if Gene Vincent suggested you swallowed a bag of flour you would.

CHAS: Well not self-raising!

RICHIE: He said it was rock and roll.

MAJOR: He said it was what! Oh Lord. Gene Vincent was in an uninsured van, ordering my employees to attack the residents of Chippenham all in the name of rock and roll.

CLEM: We didn't know it was uninsured. We're the fucking passengers.

MAJOR: No. No, Joe, the van insurance really is your responsibility.

JOE: Right, well. If you weren't so fucking tight-fisted,

I wouldn't have to penny pinch, and the van would have been insured.

MAJOR: That is of course of no help.

JOE: Major, the boys have a gig to do.

MAJOR: Of course. The summons is for Wednesday. For appearances' sake, we shall all be there, and should we face a hefty fine it shall be met by your wages. Were I on the bench I would have you all flogged. Rock and roll indeed.

JOE: Right, get going. Heinz will be driving with me and Lionel, and I'll be watching tonight so no monkey business. Heinz, wait for me downstairs. Chas. A word.

They leave except MAJOR, PATRICK and CHAS.

CHAS: Yes Boss?

JOE: Light bulb. Fucking light bulb.

CHAS: Watt?

PATRICK laughs, then covers up his laugh.

JOE: Is that a fucking joke?

CHAS: No Joe, it's not.

JOE: You don't take the piss out of our top acts you little man.

CHAS: I really am sorry, just hear my side quick.

JOE: Fucking quick.

CHAS: Have you ever seen a butterfly knife? I know some gags. When we go on the Teds are baying for blood mate. I make a couple of jokes, and, no pun intended, defuse the situation. I'd rather risk a right-hander off Mr Osram than a face full of stitches.

65

JOE: A joke! Well I have a joke for you. What do you get if you cross Joe Meek? Fired. I don't want to hear it again.

CHAS: Fair enough. Sorry.

JOE: Be off with you.

CHAS goes.

MAJOR: What on earth was all that about?

JOE: Major, I may have a new backer.

MAJOR: Really.

JOE: I've set up management and publishing companies that all have nothing to do with you.

MAJOR: I know.

JOE: As soon as I get my Telstar royalties I will buy you out completely.

MAJOR: I'm very sorry, Joe. I genuinely like you and I'm going to give you some advice. Spreading yourself too thin before you're established is more than a risk. It is, to be frank, simple, bloody-minded stupidity.

JOE: Don't you dare talk to me like I'm one of your lackeys.

MAJOR: I am talking to you as a friend. Joe you are a terrible businessman, I dread to think what will become of you with no one to mind the purse strings.

JOE: You just don't want to lose your half of the company, because you know how big it is going to get.

MAJOR: I hope you are right.

JOE: I know I'm right. Businessman? My band are number one in America and ya can't get them out.

MAJOR: It was your contract. You signed it. Until your writer's royalties arrive and you're able to instigate this

little coup, we shall enjoy the same relationship. As partners. As such I am, shall we say, curious about funds spent on Heinz. Photo sessions, posters, clothes…

JOE: Well that is where you can get off. That boy is the only one of you pigs who doesn't want anything from me.

He walks towards the control room. Lights fade.

Lights come up to reveal HEINZ in full glam. JOE records as he and the band perform 'Just Like Eddie'.

Lights fade. The radio crackles to life, and we hear:

DJ: The nominations for the forty-third Ivor Novello awards… *(Crackle.)* …The winner of course is Joe Meek for 'Telstar'.

We hear JOE speaking.

JOE: *(Voice off.)* I'd especially like to thank a very special lady, you might know her as Biddy, though I doubt it. I know her as mum.

Scene 4

Lights up on the studio. PATRICK is banging loudly on the bedroom door and shouting. JOE enters through the front door, looking dishevelled.

JOE: Go away.

PATRICK: I've been waiting for you all day. I've been calling since nine. I kept knocking but there was no answer…

JOE: I've been otherwise engaged. What do you want?

PATRICK: There's this French composer, Jean Ledout, claiming that 'Telstar' was stolen from his film score…

JOE: This is bollocks.

PATRICK: No it's serious.

JOE: I've never heard of this French bastard. Just ignore him. I've just won a Novello award for God's sake.

PATRICK: Joe you're being sued. The Major says, 'The matter is quite severe.'

JOE: I'll call him later, please leave me Patrick, be a love and sort it out, I can't see anyone today.

JOE walks into the spotlight. He pours a large glass, paces, picks up the phone and dials.

Lionel. It's Joe. I'm in a bit of a mess. I know, I only call you when I need something. Listen Lionel. I just got in from Kentish Town Police Station. I've been there since about midnight...I went to Madras Place, and... It doesn't matter. Lionel, I've been charged... Importuning in a public convenience. Oh God. I appear in court...in four hours. Oh God. It's, it's so terrible. It will be in the papers Lionel. I'm finished. I don't know what I'm going to do Lionel. What about Mother? What about Heinz? What about home...

He sits, swigs.

Blackout.

ACT TWO

Scene 1

The lights come up on JOE, tightly lit, alone in the control room. From the speakers in the room we hear voices very clearly, despite their whispered tones.

CHAS: No one's spying on him, it's all in his head.

RICHIE: He's just being careful.

CHAS: He's being mental. Hands on the Bible, swear allegiance. It's bollocks, like being in the fucking scouts. Arkela Meek.

RICHIE: Nah, that's the cubs. Joe would be Skip.

CHAS: No-one's bugging the place, it's paranoia.

RICHIE: What's that then?

CHAS: He thinks we're all talking about him behind his back.

RICHIE: We are.

JOE: *(Leans into the mike on the desk and speaks.)* I can hear talking, and I don't want it. I'm nearly ready for a take.

The bathroom door opens and we see CHAS and RICHIE bent over a miked-up toilet poised to drop marbles in the bath for a sound effect.

RICHIE / CHAS: Sorry Joe.

They count three and drop the marbles. We hear the effect echo around the studio.

CHAS: *(Covering the mike.)* Why are we doing this? Making ploppy noises in a karsey. For no money.

RICHIE: Novelty records always get to number one, don't they.

CHAS: Yeah? Well I ain't a novelty musician.

RICHIE: He's just trying to get another hit then we can all get paid.

CHAS: All? Blond rinse is doing alright. Seen his car. Zephyr Six, estate mind, with a built-in record player. And a boat. My arse is hanging out me trousers and he's poncing about on a boat. Adam Faith ain't even got a boat.

RICHIE: So, what is your point?

CHAS: Point is, if that's where the money's going, there's little danger of getting paid for dropping marbles in a fucking toilet.

CHAS slams the bathroom door shut and we briefly hear 'Three Coins In A Sewer', the song the effect is for.

Lights up on the rest of the stage. The whole cast, except HEINZ, the MAJOR and MRS SHENTON make their way through the door to the recording room. JOE is mixing in the control room. We can faintly hear a tune being played through the headphones that are laying around in the studio. PATRICK quickly ushers people to their places.

They are obviously back from a tea break and with an air of familiarity they stand together sharing or listening on headphones. GEOFF arrives a little late. He takes off his coat and goes to speak to PATRICK.

GEOFF: Sorry I'm late.

PATRICK: Shhhh. Geoff?

GEOFF: Sorry I forgot.

GEOFF stands in a scarecrow stance as PATRICK quickly frisks him. He hands GEOFF a Bible. GEOFF holds it and quickly mutters.

GEOFF: I pledge allegence to RGM records. Who's that?

PATRICK: That's Blaikley!

GEOFF: What am I playing?

PATRICK: Just go along with everyone else.

Suddenly the cast start frantically to jump up and down, stomping. They use everything they can, to make as much noise as possible. RICHIE bangs a table, CLEM hits the snare with chair legs; while realising his meagre input GEOFF sits quietly and begrudgingly tapping his foot.

MRS SHENTON bursts in, in a rage. She screams until everything stops.

MRS SHENTON: Aw my Gawd! What the bloody hell's going on. I can't have this. Stop it. Stop it now. Oh Gawd.

They all begin to laugh. Everyone stops.

I thought the house was coming down. I can't have this. It's not right. Stop it.

PATRICK: I'm terribly sorry Mrs Shenton. Joe didn't…

MRS SHENTON: Where is he?

PATRICK: I'm afraid Joe doesn't seem to be…

MRS SHENTON: Bawls, where is he?

JOE appears clutching his stomach, giggling.

JOE: I'm sorry Violet. Listen everybody, I think I've got enough there. Thanks everyone. Let's leave it there. Patrick will call you later if I need you.

ALAN BLAIKLEY, Joe's new writer, comments as they pass him in the corridor.

BLAIKLEY: Wonderfully stimulating.

JOE: Oh it's a wonderful song Alan.

BLAIKLEY: See you in the charts.

GEOFF glares at BLAIKLEY.

JOE: Patrick when you've done that make me and Mrs Shenton a nice cup of tea.

PATRICK: Of course.

MRS SHENTON: Joe, you just frightened off two of my customers with that racket. We all thought the roof was going to cave in.

JOE: It's just the chorus.

MRS SHENTON: I don't care what it is. The couple were about to buy the vinyl weekend set. *(JOE smirks.)* It's not a laughing matter. To be frank, Joe, business has been more than slack, and, well to be honest I could blame this studio for the fall in passing trade.

JOE: No, really Violet, I'm two flights up.

MRS SHENTON: This has always been a good spot, we've a lovely gold leaf polished window, but over the years we've had stage coaches, hearses, motorbikes, cowboys, sheep and that twenty foot stuffed crocodile outside the door scaring people off.

JOE: I should think that was good publicity. I mean it's bound to get people's attention.

MRS SHENTON: Nobody wants to go into a shop if they have to step over a crocodile. Not in Islington.

JOE: You're right Violet. I should have got him to leave it in the stockroom.

MRS SHENTON: And that's without all the noise. And now, well, with those bother boys, hanging 'round of an early evening after your thing in the paper.

JOE: I'm sorry Violet.

MRS SHENTON: Business is slow, and, well there's no polite way to put this, you're over a month in arrears with your rent.

JOE: Really? Oh dear. Violet, I had no idea. You see that's the Major's department. Oh that makes me so mad. Violet, he is a crook, I don't mean to be harsh, but there it is.

MRS SHENTON: Really?

JOE: Really. Once I've settled things with this Frenchman and I get my royalties, I shall be well shot of him.

MRS SHENTON: My father would never trust a toff. Not when it comes to money.

JOE: I'll see you right about the rent as soon as I see him.

MRS SHENTON: Well, that would help.

JOE: And I'll see if I can do something about those rough lads.

MRS SHENTON: Well I don't see how.

JOE takes her into a corner and whispers.

JOE: They've been sent by other record companies. To put me off.

MRS SHENTON: Really Joe?

JOE: *(Louder.)* It was them that engineered that horrible thing in the papers. I wouldn't do that. *(Whispers.)* How many of those boys do you recognise from round here?

MRS SHENTON: Well, Joe, we both have our crosses to bear. We didn't really know what a recording studio was when we agreed to the lease, but we know what it is now. Noisy.

PATRICK enters carrying a folder under his arm.

PATRICK: Tea Mrs Shenton?

MRS SHENTON: No thanks love, you have it. I best open up again while it's quiet. Toodle-ohh.

She goes.

PATRICK: Joe. Post.

GEOFF: Did you mean that? About Major Banks, and about those hooligans downstairs?

JOE: Of course Geoff. Why wouldn't I?

PATRICK: We have *(Goes through folder.)* returned invoices from the Major, wants to see receipts of Heinz's expenses.

JOE: Tight-fisted pig.

PATRICK: Particularly his boat.

JOE: It's a fucking asset, and it's good press. No-one's got a boat. Not even Adam Faith's got a boat. Send him some of those photos of Heinz fishing.

PATRICK: Well, I don't know about that Joe, he's also returned an invoice for Heinz's photo sessions.

JOE: I'll call him later. Tight bastard.

PATRICK: There's a, looks like, yes…blackmail. I'll bin it.

JOE: No read it. It's alright Patrick perhaps Geoff would like to hear.

PATRICK: 'You had my brother, he was only sixteen. I'll go to the pigs and tell them about scum like you, we know where you live…'

JOE: Who doesn't. Go on.

PATRICK: I'll put it in the bin. Another one…photos of you in Hampstead Heath. 'I know what you did there, I've seen what you do. Does ya mam know?…'

JOE: He'd done his homework. Next.

PATRICK: 'I hope you rot in hell. I hope you see all your loved ones scream in agonising pain…'

JOE: That's a bit strong!

GEOFF: Dear God, what do they want?

PATRICK: *(Turns paper.)* Nothing, that's the neighbours.

JOE: Bin.

GEOFF: How long have things been like this?

JOE: Since my little court case made the papers.

GEOFF: What? That tiny thing in the Sketch?

PATRICK: Standard.

JOE: Perhaps if you'd been around a bit more often, then it wouldn't be such a shock to you. Patrick, can you leave us for a while?

PATRICK: Of course. I'll sort these out. *(Goes.)*

GEOFF: *(Pause.)* So you're recording one of our old tunes.

JOE: What?

GEOFF: Yes, I recognise it. It's very good – what you've done with it.

JOE: I don't blame you Geoff, but you would say that.

GEOFF: Why?

JOE: Well, because it's the first tune that I've done that hasn't been written by either of us. There has been a lot of criticism of late, saying that RGM have been sounding, well, old-fashioned, Geoff. Maybe it's because of your classical training, or maybe you've been spending too much time on your psychic studies, but the point is, you've let the side slip and I can't allow it to happen anymore.

GEOFF: Are you… Are you firing me?

JOE: I'm running a business with or without your help, and I've been running without your help for some time Geoff.

GEOFF: If my writing is so old-fashioned, then why are you recording one of my old songs?

JOE: That song was written by my new boys Blaikley and Howard. It's got nothing to do with you. We've not seen much of you since our little court case, have we? A friend in need Geoff.

GEOFF: No Joe.

JOE: Well, what then?

GEOFF: I…I got scared. I'm not from London, those boys sense that. They scare me.

JOE: I can't leave the house. And you can't write songs if you're not here.

GEOFF: I couldn't write even if I was.

JOE: Why?

GEOFF: I don't feel comfortable anymore. This place… it's changed. It used to have a warm aura. Now it's gone.

JOE: What do you mean gone?

GEOFF: You can feel it can't you. This place used to radiate. Everyone gave something into the ether and together we created miracles, but you got big-headed. You swallow up everybody's energy like, like a vampire.

JOE: Fuck off Geoff. You're a mediocre talent who's been lucky to work here.

GEOFF: Then why are you recording something that sounds like one of my old tunes?

JOE: That tune has nothing to do with you or me. It was written by my two new boys.

GEOFF: Oh, she didn't steal it? That's a first!

JOE: You fucking weasel. You're just jealous cos they write better songs than you, and so you're out of a job.

GEOFF: They won't have to write for your pretty, tone deaf pudding. Who always sings a guide track for him? I'm normally louder on the record than he is.

JOE: You see? Fucking jealous, you're a sad, jealous boy.

GEOFF: I'll give you jealous. Your cherub's already moved out. What do you think he's been doing on tour? Been sleeping alone?

JOE: *(Pause.)* I don't want to see you anymore.

GEOFF: You wouldn't be here if it wasn't for my songs.

JOE: You've always been an embarrassment to me.

GEOFF: *(Pause.)* I wrote hits for you Joe. I…every good idea to come out of… If that song's off an old tape then I wrote it.

JOE opens the door.

JOE: Patrick!

PATRICK: *(Runs upstairs.)* Yes Joe?

JOE: Where is Heinz?

PATRICK: Back off the Tremolos' tour last night, but he's coming over later.

JOE: *(Staring at GEOFF.)* Good. Send him up as soon as he gets here. Show Mr Goddard to the door, Patrick. Thanks for all your help Geoff, but we shan't be needing you anymore. *(Goes upstairs.)*

PATRICK: Come on Geoff.

GEOFF: He's changed. It's all changed. It's such a shame.
It's all different now. Like a big game. Big pantomime.
These songs come to us from somewhere out there,
and we do all of these powerful things because of them.
It's not a game. I can see the path he's going down.
It's dark, and cold and I fear it may cost him everything.
Be careful Patrick.

PATRICK: Goodbye Geoff.

GEOFF: *(Pause.)* Tell him to look out for the few friends he
has left.

PATRICK: I will.

GEOFF goes. PATRICK follows.

*The studio is bare and silent for a moment, then very loudly
from upstairs we hear 'I Guess It Doesn't Matter Anymore'
by Buddy Holly.*

*JOE is in the control room when CLEM enters the studio.
CLEM seems to be searching for something, his fags maybe.
He pats his pockets for a final check then starts rummaging
through the junk near Joe's 'Black Box' and out of curiosity
gives it a brief inspection. The machine is switched on. JOE
hears the noise from the control room. He marches through
the door and glares at CLEM.*

CLEM: I was looking for me fags. *(JOE says nothing.)*
I've found me fags. I'm off, I'm not snooping about,
alright? Don't fucking look at me like that. You know
what you're doing don't you. Creeping about like Dick-
fucking-Barton. No-one trusts anyone. Talk about shit
where you eat. Look, here, Woodbines.

JOE: Woodbines in a bass drum?

CLEM: Oh! For fuck sake!

JOE: In a bass drum!

CLEM: Oh, fuck this, yeah I was poking about with your fucking echos, I've been stealing your tapes, and live in a big fucking house with Phil fucking Spector….

JOE: Why Clem? Why?

CLEM: You really are fucking mad. Can't you see? You're ruining it for all of us.

CLEM goes to leave.

JOE: Get OUT!

CLEM: I have been doing other sessions. Doing this new band 'The Kinks' on Wednesday. People do ask us about you Joe. Sometimes. I just tell 'em he's a nice enough bloke, but a clueless tone-deaf bastard who lucked out one time.

JOE: You fucking Judas!

CLEM: I'm going Joe. But you've been gone a long time.

CLEM hands JOE his drumsticks and leaves. JOE picks up a tape recorder and throws it at the door as CLEM exits. Fuming, he inspects the echo unit. There is a knock at the door. JOE stands up quickly and takes off one shoe.

HEINZ enters.

HEINZ: *(Sings.)* 'Oh what a glorious thing to be…' It's me you miserable bastard. Picking some stuff up. Moving into me new digs. Handsome it is. Here, I'm doing the Arthur Askey gig tonight, you coming? *(Sings.)* 'I'm a buzzy buzzy bee, on a buzzy…'

JOE hits HEINZ hard across the face with the shoe.

What's that for?

JOE: Who is it?

HEINZ: What you on about?

PATRICK enters.

PATRICK: There's someone to see Heinz, downstairs.
It's a girl.

JOE: Who is she? You've been covering your tracks
haven't you?

HEINZ: Tongues wag Joe. Since your thing in the paper.
It's good for the image, having a girlfriend.

JOE: What fucking image? I give you your fucking image.

HEINZ: *(Pause.)* I'm not like you.

JOE: Get out. Leave your stuff. Go on, go if you're going.
I've got work to do. *(HEINZ leaves.)* Go if you're
going... Fucking go.

*HEINZ is gone. JOE goes to the control room, gets a grip and
takes some pills, and starts mixing feverishly. We hear 'Have
I The Right?' by The Honeycombs, after mumbles in and out
of phase, and hearing instruments isolated we suddenly hear
crystal clear, very loud:*

'Come right back, I just can't bare it.'

JOE holds his head in hands.

Lighting change, JOE leaves the booth.

The radio lights up and plays 'Have I The Right?'

DJ: *(Voice of Jimmy Young.)* Well it's there at number one.
The Honeycombes with 'Have I The Right?' But can it
keep those boys at number two off the top slot? It's The
Kinks.

*PATRICK ushers the MAJOR in and sits him in a chair.
After a few seconds, JOE enters and hands the MAJOR a
folded piece of paper. The MAJOR then passes JOE a folded
piece of paper. JOE unfolds it and looks at it.*

MAJOR: How was Spain?

JOE: Ibiza. Refreshing.

MAJOR: I would have been prepared to be talked down you know. I'd have settled for a lower figure.

JOE: It doesn't matter.

MAJOR: I am, of course, dreadfully sorry that things have to end like this. I still think that you are being terribly silly Joe.

JOE: Really.

MAJOR: As a partner, former partner, I know exactly how much money you made from the latest record. I know that figure will clean you out…

JOE: It's worth it.

MAJOR: You should have waited until after the Telstar case, if you lose there would have been two of us to share the blow, and if you win then you could've bought me out with your own money.

JOE: Really.

MAJOR: As it stands, you have just spent your every penny buying half of a firm which is in debt and losing money.

JOE: This is sour grapes. You are sore at losing what will be the biggest recording and publishing company in the country. Just look at the charts. I'm number one again and it's just the start.

MAJOR: Of course. Patrick, is there any truth in the rumour that Geoffrey is suing for copyright?

PATRICK: A bit of confusion over authorship. That's all.

MAJOR: Oh dear. Look after your men Joe, they're the only thing looking after you.

JOE: Thanks very much for the advice Major. Now goodbye.

The MAJOR leaves gracefully.

PATRICK: What now Boss?

JOE: Once bitten Patrick. *(Thumbs through contract.)* I'm going to sell the shares to Tony Shanks. He's a lovely man. A true gentleman. Let him look after the business end. I trust him. I've a good feeling about all this.

Blackout.

Music: 'It's Hard To Believe' by Glenda Collins.

Scene 2

Lights up. JOE is standing over the drum kit, pointing a shotgun at SIMON, nineteen, fuzzy-haired, the new in-house drummer, CLEM's replacement.

JOE: If you don't play it properly I'll blow your fucking head off.

JOE goes back to control room.

I'm recording.

SIMON plays along, in tears. The tension is incredible. SIMON breaks down. He stands, wobbles, then collapses.

CHAS: Alright mate?

RICHIE: Sit down, get your breath.

CHAS: Yeah, put your head between your legs. You're alright.

RICHIE: Yeah, deep breaths.

PATRICK enters from control room.

CHAS: What the fucking hell's the matter with him?

PATRICK: Joe says…

SIMON: Oh God, no.

PATRICK: Joe says that's fine. You all break for a long lunch.

RICHIE: Fucking nutter! Where did he get that from?

CHAS: Heinz used to have it on tour with him. He used to get a lot of jip, you know, threats and that.

RICHIE: Wanker.

CHAS: I ain't seen it for a couple of years.

SIMON: I'm gonna be sick.

CHAS: You're alright mate. It's all over.

SIMON: *(Noticing.)* Oh look, I've fucking pissed myself!

PATRICK: He's been under a lot of stress lately.

RICHIE: Bollocks. *(Shouts.)* He's a fucking wanker. And, he's fucking sick.

PATRICK: I'm sorry Si.

RICHIE: No excuse. Dirty fucker.

CHAS: They're just tunes mate. It's 'posed to be a laugh.

SIMON: I got to get some air.

RICHIE: Course you have mate. Come on.

CHAS: It's supposed to be fun.

SIMON: I've had more fun at the dentist's.

PATRICK: It's the pressure. He didn't mean nothing. I'm sure he will make it up to you.

RICHIE: Oh yeah, how? Fucking gun in the face… Arsehole.

CHAS: Come on mate, I'll get you a brandy and stout, that's what you want.

SIMON: I'm gonna spew.

They all leave.

RITCHIE: *(Leaving.)* He wouldn't've pulled a gun on Clem would he?

JOE enters.

JOE: Bunch of girls. I would have shot Clem. *(He takes another pill.)*

PATRICK: How did you hear that?

JOE: I like to keep the room's mike on. See who I can trust. It's not paranoia.

PATRICK: Of course.

JOE: Keeping tabs.

PATRICK: Did you see her?

JOE: *(Sings.)* 'It's hard to believe, but I do.'

MRS SHENTON enters.

PATRICK: Hello Mrs Shenton.

MRS SHENTON: Sorry Joe, only I saw all the boys leaving and thought it might be a good time to catch you alone. The one with the hairdo, the new one, looked anaemic.

JOE: *(Sings.)* 'It's hard to believe but I do.'

MRS SHENTON: I need to ask about the rent situation. Oh that's a nice thing.

JOE: Oh, it's a portable tape recorder. Runs on batteries you see. I use it to help with my recording.

MRS SHENTON: You made it yourself. You are clever. Thing like that could catch on. It's good that you started with a trade. Fixing wirelesses and televisions. You'll always have that to fall back on. I mean if you had to.

JOE: I'll just leave it here, in case I have any ideas while we're talking.

MRS SHENTON: Well…

JOE conspicuously places the tape recorder where her voice will be clear.

JOE: Sorry you were saying about the rent?

MRS SHENTON: Yes well… I know you've always done fair by me in the past, even through that lean patch last year, but you are three months behind, and I got the mortgage payments.

JOE: Yes, Violet. Take a seat. Well, I'll explain. My new partner, Tony Shanks, the polite man with the white beard is a crook. He's said some wicked things about me behind my back, he really did, and when I asked him to leave the company he asked for thousands and thousands of pounds of backdated wages.

MRS SHENTON: Charming.

JOE: Then Roger, with the thick head of hair who played piano for the Tornados told the tax people that he'd never been paid for all those hits that I let him play on, and so the Board of Trade want to see my books, but that nasty Mr Shanks has got all the books, and he won't give them back until I give him all these thousands of pounds that he says I owe him. But I don't have any money to give him…

MRS SHENTON: I don't understand any of that palaver, and I don't understand why it means I don't get me rent.

JOE: …All I need to do is write another hit.

PATRICK: I'll make the tea. *(He goes.)*

JOE: I'm sorry.

MRS SHENTON: I'm going to Canvey Island next month. Going to stay in one of those lovely bungalows. They're very cheap. We stayed in one last year.

JOE: You see I pay so much for legal advice. All my legal advice tells me not to pay you any rent.

MRS SHENTON: Oh.

JOE: *(Singing into tape recorder.)* 'It's hard to believe, but it's true.'

MRS SHENTON: Oh.

JOE: *(Points to a piece of paper covering the window.)* Read that. *(She reads.)* Parliamentary candidate Screaming Lord Sutch declared he is owed thousands by record producer Joe Meek…in the paper Violet. 'Et tu Sutch.' The knives are out for me on all sides. It never ends. I'm being ripped from pillar to post. Everyone just… I don't know what to do. I don't have anything to give 'em.

JOE starts to break down. MRS SHENTON puts an arm around him to comfort him.

MRS SHENTON: There, there. Everything will be fine when you get your Telstar royalties. Then you'll be rich as Solomon.

JOE: That French liar, his song has ruined my fucking life. Sorry Violet.

MRS SHENTON: Pardon my French you should say.

JOE: What? Oh yes, quite. Anyway, I'm well on the way to proving him a proper chancer. We had a professor

in here explaining it. You see 'There are similarities in many great works.' He says, 'It is the tempo and flavour of the piece that is the crucial factor in differentiating between them. To quote a popular example used by musicologists, which is what they're called, one could declare that "Yes We Have No Bananas" could be attributed to Handel's "Hallelujah Chorus" and the traditional Celtic mariners' song, "My Bonnie Lies Over the Ocean". So the first lines would go "Hallelujah Bananas, Oh bring back my Bonnie to me." '

MRS SHENTON: You should go on holiday.

JOE: I'm thinking of going to Cairo. A medium has told me that one of my guides is Rameses the Great, the mighty Pharaoh.

MRS SHENTON: Well fancy.

PATRICK enters.

PATRICK: Joe, he's downstairs. I can't…

HEINZ bursts in dressed as a farmer.

HEINZ: Out my fucking way.

PATRICK: …keep him out.

HEINZ: There you are.

JOE: Of course, I'm here.

HEINZ: Yeah, well.

JOE: Patrick, didn't you mention tea? Two cups and a couple of rich teas.

PATRICK: Yes Joe.

JOE: Take a seat.

HEINZ: I don't want a fucking seat, and I don't want none of your fucking biscuits either.

JOE: Really, what do you want?

HEINZ: I want me car back.

JOE: That's not all you want is it?

HEINZ: No, I want me boat. I was gonna use it for me holidays.

MRS SHENTON: I'm going to Canvey Island to look at some bungalows and caravans.

HEINZ: Oh, well bye then.

JOE: I'm so sorry. Biddy…Violet. *(To HEINZ.)* We were having a conversation. *(Turns back to MRS SHENTON.)* Please, you were saying.

MRS SHENTON: Don't you worry about that thing of ours. I'm sure we can sort it out. You've enough on your plate. People take advantage of your nature.

JOE: Thank you Violet.

HEINZ: I just come out of EMI, dressed like this and there's some bloke with this bit of paper. Heinz Burt Ltd, and he takes me car. Zephyr Six Estate. I had to watch him drive off. I been phoning. Soppy bollocks there tells me Joe's here, there or some fucking where else.

JOE: I have other artists. I have been busy.

HEINZ: You been here though ain't yer.

JOE: Well, we mustn't always believe what we hear.

HEINZ: And what's happening with me boat, Globetrotter, bloke with papers, what's its *(Makes phone gestures.)* receiver, whatever, blah blah, Heinz Burt Ltd, you owe this money. Gone it was. Nothing on the end of the jetty. I don't owe no one a thing. On Sunday that was. All me stuff's gone and all I got is handfuls of paper.

JOE: And?

HEINZ: And, I want it back. Can't stick me with your fucking debts.

JOE: You know that myself and Tony Shanks have had a terrible tiff.

HEINZ: So?

JOE: So, your secret chats, behind my back, did nothing but give him something to hurt me with. You dumb bastard.

HEINZ: I asked him for advice.

JOE: You asked how you could get out of your contract.

MRS SHENTON: Joe I really should be off, I've left…

JOE: Don't be embarrassed Violet. There's no secrets between friends.

HEINZ: Yeah, I don't know much about contracts and that…

JOE: Because I'm your manager, I look after you. You don't need to know about them.

HEINZ: If you're me manager, how come you never stopped them taking me boat?

JOE: I took your boat. It's a company asset.

HEINZ: You…you slag. I want me car you slag.

PATRICK enters with tray of tea.

PATRICK: Tea's up.

PATRICK starts handing out cups of tea.

JOE: You don't owe anything? I think you do. I think you owe me. How dare you try and creep out of our contract after all I did?

PATRICK: One sugar Mrs Shenton? *(MRS SHENTON nods.)*

HEINZ: Southend, Scunthorpe, Bognor, Margate. You put me on that shitty sea-side tour. I'm fucking sick of it, and don't think I don't know why I'm doing it, cos I do.

JOE: Really. Because you're an entertainer perhaps? And people go on holiday to be entertained, don't you agree Vi?

MRS SHENTON: They had a hypnotist at Canvey Island, made a man eat a raw onion… It was horrible.

HEINZ: You are trying to keep me away from Della.

JOE: Well, that's not true. How is she?

HEINZ: She's fine thanks.

JOE: Good. And your mother?

HEINZ: Touch of angina.

JOE: Poor love!

HEINZ: And why am I doing covers? I've been number five and number one in Sweden.

JOE: I know.

HEINZ: Number one in Sweden, so why am I doing covers? I need a follow up not some farmyard crap.

JOE: 'Digging My Potatoes' is a traditional song. We all used to sing it when I was a boy. Besides, it's a very catchy tune, isn't it Vi?

MRS SHENTON: I really don't recall.

HEINZ: It's hardly rock and roll though is it.

JOE: It just needs a good bit of promotion.

HEINZ: Don't you start talking about promotion. You just

had me handing out jacket spuds to all the EMI top brass dressed as a fucking farmer.

JOE: Didn't it go well? Very colourful.

HEINZ: What's colourful about fucking farmers. That's not promotion, that's…that's bollocks.

JOE: Oh, well it wouldn't be bollocks if The Beatles did it.

HEINZ: The Beatles wouldn't've done it.

MRS SHENTON: Ooo, I like the Beatles.

JOE: Don't dare try and tell me my job my lad.

MRS SHENTON: Paul's my favourite.

JOE: I do happen to know my job.

HEINZ: Yeah, well you ain't done it lately have you.

JOE: Were it not for me you wouldn't be digging potatoes, duckie, you'd be slicing fucking bacon. Don't say you don't owe anything, because you fucking owe me. You owe me for everything you've got.

HEINZ: I ain't got nothing though have I. I got no car, no boat, and no fucking follow up.

JOE: And you nearly had no contract.

HEINZ: If you can't look after me I'll find someone who can.

Silence.

JOE: I made you and I'll break you.

HEINZ: I'm broke already. I want me Zephyr back.

JOE: Oh get on a fucking bus.

HEINZ: You've had hits all over the world, you made a packet out of me.

JOE: You cost me, every time you've had your picture took, every interview, every record that gets pressed and never sells costs me. Half the time you're in the fucking charts costs me, I pay for all that up front.

HEINZ: You old fuck, I'll kill you, I'll fucking murder you.

HEINZ lunges at JOE: there is a vicious fight, HEINZ grabs JOE, MRS SHENTON intervenes, she grabs him by the ear and drags him to the door.

MRS SHENTON: Out of my property you fucking parasite.

HEINZ raises his hand to hit her.

I bet you would you rotten little bastard. *(She slaps him.)* Two wars I've been through. I'll be doing the murders in this house.

As MRS SHENTON and PATRICK bundle HEINZ out, PATRICK tries to comfort him, but he shrugs him off. PATRICK leaves. JOE is left alone screaming hysterically.

JOE collects his thoughts, calms himself, and picks up his tape recorder and begins to record himself; this speaking not singing.

JOE: Dear Mr Gilette, As my lawyer there are a few things that you should know about, no, be aware of especially before, no, I, I want you to know me properly so as you will not be influenced but what others say, are saying about me.

There is a massive crash at the door followed by tremendous noise downstairs. The studio door bursts open. Three men in suits and raincoats enter, one of them approaches JOE. JOE grabs a mike stand. He is quickly seized from behind.

MAN 1: Steady Sir.

MAN 2: Robert George Meek, we are officers from Her Majesty's Board of Trade and Commerce and after

several requests for receipts of trade and income, have been authorised to remove any papers, dockets or receipts which we feel will help with our enquiries.

JOE: No please, don't go in there.

MAN 2: You are not obliged to stay in the building, but should you leave this will be noted by me and my officers and will be mentioned should the enquiry proceed any further.

JOE: You're wasting your time. I don't have the books. Tony Shanks has them. He won't give them back.

MAN 2: We are fully authorised to seize goods to the value of your outstanding bills and court orders resulting from County Court judgements and warrants.

MAN 1: Stinks in here don't it.

MAN 3: Musky

MAN 1: Here don't you ever open a window.

JOE: He'll… Mr Gilette my lawyer will tell you. It's not me, it's Shanks.

MAN 3: I think the place could do with some air.

JOE: No. No please don't do that.

One of the inspectors starts to pry open a sound-proofed window. Daylight pours through the opening bathing JOE, who shrieks.

No. You see what they'll do Patrick? Do you see how far they will go? Do you see now?

The background begins to darken, and we are left with JOE alone lit by intense sunlight. He slips into a trance. After a moment JOE scrambles for his tape recorder again. He starts to recite a letter to Mr Gilette. He slips in and out of the trance as the stage is laid bare by the bailiffs.

Mr Gilette, Why is everyone out to hurt me? I just need a friend. I don't understand some things...numbers and paperwork, that doesn't make me bad. It seems that all the things I'm not good at is what people use to hurt me, and all the things I am good at doesn't help. Why are they out to hurt me? Please help. Please be my friend. Yours sincerely, Joe Meek.

JOE is left motionless stage centre. The studio is bare. He is in a deep state of trance.

Scene 3

We hear a phone ringing. The lights come up on JOE, standing stage centre, dishevelled, halfway through painting a picture. The easel and canvas stand centre stage. He is still in a deep trance. The studio is a mess. There are few instruments and much of the equipment is gone, however the mess of cables and wires is worse than ever. The phone stops ringing. The radio plays a news report on the Aberfan disaster, which bleeds into 'Elenor Rigby' by The Beatles. After a while PATRICK enters. He is holding a paper bag with some food in and a paper. He has gone from a mod look to more hip. He sees JOE's state, and calmly turns off the radio, and gently moves JOE to bring him round.

PATRICK: Joe. Wake up Joe. That's it Joe. Yes it's me.

JOE: Did I… Was…was I off again?

PATRICK: Miles away.

JOE: Tablets. Find my tablets. I was…I was painting. Tell me, what do you think?

JOE goes to a jacket slung over a chair and finds a pill box.

PATRICK: *(At picture.)* Anyone we know?

JOE: No.

PATRICK: You shouldn't take those.

JOE: They help me think.

PATRICK: And the other ones.

JOE: They help me relax.

PATRICK: You should see Doctor Crispe about those trances.

JOE: He'd only give me more pills. Last thing I need is a doctor's bill.

PATRICK: You don't get doctors' bills anymore silly.

JOE: No. No of course.

PATRICK: I pinched a bit of steak from mum's larder. It's a bit dry but it should be alright. We've got some spuds. I thought I'd make us some tea.

JOE: You are so very kind. You've always been good to me. I'll see that you are always looked after.

PATRICK: Pardon Joe.

JOE: In case I won't be around much longer.

PATRICK: What are you talking about?

The phone starts to ring again.

JOE: Leave it Patrick. *(The phone stops ringing.)* Loose lips sink ships.

PATRICK: Have we got any ketchup?

JOE: They want to take my boys away.

PATRICK: Who?

JOE: The… The twins… Krays. They saw The Tornados at the Aberfan Relief gig. They want to manage them.

PATRICK: What did they say?

JOE: *(Finger to lips.)* Walls have ears. Did you get a paper?

PATRICK: Yeah, *Daily Mirror.*

JOE: Does it mention any more about the suitcase murder?

PATRICK: Front page. 'Police Find Remains.'

JOE: Be a love, read it to me. My eyes hurt. It must be all this painting.

PATRICK: Joe, you should take EMI's offer. Work for them. Let them manage the acts, pay the bills and do the tax returns. You've had enough bad luck in this place. You've proved your point. You should move on. Work at Abbey Road.

JOE: My real name is Robert. Robert George Meek. My Gran named me Joe after her son. Uncle Joe. He died in the Great War. An officer, young lad, made him take up a maxim gun post, where he knew he would be shot. He did it, and was shot through the face. I try to contact him sometimes, but he's very distant. Very tense. The officer saw this then ordered the next man to put the body down and take up his place. Well the next man was my father. He did it. He fought like mad, he was hit, but he was lucky and he survived. He had to convalesce a long time. Years. He has some shrapnel lodged in his skull, but it was the shock you see. The shock did the damage. Then he met mother. But all our lives he never worked a day for anyone else. He could never have anyone order him about ever again. It would make him mad. The shrapnel would move and he would smash up the village, and spent all night screaming. So he was always his own boss you see. He had to be. Anyway that's why I'm called Joe. *(Pause.)* I can't work for someone else Patrick. Everything I tried to do is here.

PATRICK: I'll make the tea.

PATRICK exits.

HEINZ appears in the doorway. He is drably, casually dressed. His hair is flat and a natural dirty light brown.

JOE: I used to look at you and I'd be so glad to see you. You'd lift me up. Now I can't help seeing you *(Slaps his head.)* bearing down on me, you and all the other bastards.

HEINZ: I've come to sort out the money you owe us.

JOE: Please go home Heinz, I don't owe you anything.

HEINZ: Thing is I could go to the solicitor, but that costs. I don't want to get heavy handed…

JOE: Are you…are you threatening me?

HEINZ: I need the money you owe me.

JOE: I don't owe you money. I fucking don't, I don't…! I DONT…!

HEINZ: Bullshit.

JOE: I did everything for you. You don't know…I sweated blood for you.

HEINZ: Well it weren't enough. It didn't fucking work. I've got… I got a job Joe, Jesus a job. You fucking lied to me.

JOE: I loved you.

HEINZ: You make me sick. When I think about us, it makes me sick. I heard you was a bender. I had your number from the start. Thought I could play you along for a bit. You're the mug.

JOE: You liar. You fucking liar.

HEINZ: No, you're the fucking liar.

JOE: I know what I am.

HEINZ: A sick, bent, fucking crook. Who owes me money.

JOE goes into one of his customary fits of temper, but his heart is not in it, he is too hurt. He throws a cup, a phone and picks up a chair. HEINZ retorts, he knows what to expect. He throws a table on its side, and picks up a stand. He holds it over JOE cowering in the corner.

I'll get what I'm owed.

PATRICK bursts in holding the shotgun and confronts HEINZ.

PATRICK: If I see you again, I'll kill you.

HEINZ: Bender.

PATRICK escorts HEINZ out.

JOE: Well, you did it. I know you can hear me. You can hear me. You done it. You took him. You won. You hear me, you fucking won.

JOE starts to wreck the place, smashing furniture and breakables, there are noises of echoes and speeded up whispers, and a steady slow low thud. He places a chair in the middle of the room and starts talking to it, as he does so, he places a waste paper basket in the middle of the room and places a pile of effects next to it. He goes to a corner and as he starts to speak he changes into a black shirt.

Please hear. Someone has been stealing from me. From my mind. My ideas, my…and now I am not myself. There is someone…in me. Sometimes I talk it's not my voice. I tried not speaking, not thinking but it finds a way. Sucking everything out and taking it somewhere. I know you understand. Where, where does it go?

JOE takes some matches and, placing the paper in the waste paper bin, starts a fire, destroying his personal effects.

(Pause.) My music is no good anymore. If you gave back my…I wish someone loved me. You love somebody and they just take from you. They ruin you. They ruin you inside then everything else gets ruined. They get famous then he…and now my music is no good. I can't help myself if I'm not myself. Please make it stop. Tell me what I have to do to make it stop. *(Pause as he listens.)* I understand.

By now the studio is chaos. Drawers tipped and emptied on the floor. Papers ripped everywhere. The radio is on and plays white noise. JOE takes another bundle of papers, puts them in a tin waste paper bin and burns them.

PATRICK runs down from upstairs. He is half awake and dressed in his pyjamas.

PATRICK: Jesus Joe. I thought the house was on fire. Having a clear out?

JOE looks at him in silence. He is very intense. PATRICK looks at the wreckage of the room. JOE writes on a piece of paper 'Make me coffee' and holds it up.

Make me coffee. What's this all about?

JOE lights the note.

Alright Joe. I'll put the kettle on. You haven't had any kip. You should try to put your head down. You been at it all night? How, how did it sound? Did you mix my song yet?

JOE writes 'Shut up!' on a note and burns it.

Shut up?

JOE stops himself from speaking.

Joe, I'm going to call the Doc, get something for your nerves.

JOE stares at PATRICK very intensely. JOE nods, PATRICK leaves to go downstairs.

JOE takes his picture of the Dancing Children from the wall. He starts tearing it up. He starts to cry. He goes upstairs.

PATRICK comes back in, drops the coffee, and runs to stamp out the burning picture frame.

JOE solemnly comes back downstairs and before PATRICK can speak, hands him a note:

What do you mean 'Goodbye'?

JOE goes back upstairs. We hear Tchaikovsky being played.

Good sign.

PATRICK looks through the debris. The door bell goes. PATRICK leaves to answer the door. The music stops. JOE comes downstairs. He has the single-barrelled shotgun in his hand. He goes to the door and bolts it. He cocks the gun and looks down the barrel.

PATRICK bangs on the door, breaking JOE's concentration.

Joe. It's Michael and his friend, those school kids.
You said they might earn a couple of bob stacking tapes.

JOE: Tell them to fuck off.

PATRICK: *(Leaving.)* Sorry boys…

JOE goes to the window that has been forced open. He takes an acrimonious last look at the world as the music swells. Something in the garden catches his attention and he explodes with anger…

JOE: Get Mrs Shenton up here.

JOE composes himself. He is very tense. He settles on the wall beside the door, and lifts the bolt.

PATRICK follows MRS SHENTON up the stairs. They stop just before the door.

PATRICK: He recorded me singing last night. Out of the blue it was.

MRS SHENTON: Nice for you.

PATRICK: Yeah. He just said, 'Come on then, let's do it.' I haven't heard it yet.

MRS SHENTON: I'm sure it's lovely.

PATRICK: Little ambition of mine, it's been…singing.

MRS SHENTON: What sort of mood is he in love?

PATRICK: Not good.

MRS SHENTON: I'll calm him down. Here, hold this will you love? I don't like to smoke in there.

She gives PATRICK the ciggie, and goes into the studio. PATRICK puffs on the ciggie as the lights fall on the stairs and rise on the studio.

MRS SHENTON opens the door. JOE stands behind the door. As she enters he is behind her. He raises the gun.

JOE: I want a fucking word with you.

MRS SHENTON: Oh God, Is that… Is that real… Is that loaded?

JOE: Don't talk back answer the question.

MRS SHENTON: What… What question? You didn't ask a question!

JOE: I'm not stupid.

MRS SHENTON: Please Joe, you're frightening me.

JOE: Why does everyone treat me like I'm stupid?

MRS SHENTON: I'm not saying you are love.

JOE: Who is he?

MRS SHENTON: Who is who?

JOE: *(Shouting.)* I told you once I'm not fucking stupid. If I was stupid people wouldn't be out to ruin me. Who was the man standing in the garden in the crombie coat?

MRS SHENTON: I'm sorry Joe, really I am.

JOE: No not stupid. Maybe I'm blind. Someone helped them…someone let them in…had…help…from the inside. How long? For how long?

MRS SHENTON: I tried to drop some hints. I tried to tell you. Please put that away. I'm very sorry.

JOE: Who are they? Who are they? I want to know who you're working for.

MRS SHENTON: Sorry…I…don't follow.

JOE: *(Screaming.)* Who does he work for? Who does he work for?

MRS SHENTON: He's just the agent.

JOE: An agent?

MRS SHENTON: An estate agent. I tried to tell you Joe.

JOE lowers the gun. There is a pause.

We're not as young as we were, and well, you've been terribly bad with the rent. Business is very poor. Everyone goes up the West End. I let them in a couple of times. He had to measure.

JOE: Estate Agent?

MRS SHENTON: 'Course.

JOE starts to rummage through his own debris of documents and papers.

JOE: Where's the book. Where's the book. Give me the fucking book. The rent book.

MRS SHENTON: I think it's downstairs. Why don't we pop down and have a nice cup of tea?

He continues his manic search.

JOE: Get me the fucking book!

MRS SHENTON: Your lease is up this month. I'm…I told you. I'm retiring to Canvey Island I didn't want to tell you like this. The bank next door. They want to expand. They asked…to see the place. Evaluate. The shop was always our nest egg… And besides, I've go to think about Gordon. He's an odd age. I don't like the way you look at him.

JOE: You let an estate agent in here?

MRS SHENTON: Yes Joe. He needed to see the place. To do a survey. Before they could make an offer.

JOE: I always thought there was something wrong. I knew there was something wrong. Going mad I was. Not myself. Losing myself you see. I thought everyone was out to hurt me. All these people were out to get me. I though there was a curse. But I wasn't sure who. I thought it was that bastard George Martin. Thought it was fucking Phil Spector or…or any of those other cunts…but it wasn't. It was you. It was just you. Selling my home while I was in it. The place I built from nothing. The place I lived and toiled in for seven years. The place that everyone got fat off. Made millions and millions, and millions and millions of people happy, and you were trying to sell it. You were trying to kill it. It was you Violet. It was you. You you fucking YOU!

He raises the gun and cocks it.

What's the date Violet?

MRS SHENTON: What?…er…the third. February third.

JOE: You see. Sometimes messages are for more than one person.

MRS SHENTON: No Joe, don't. Please don't.

She turns to run. She gets to the door. JOE steps up to her and fires, close range. The force of the shot forces her out of the doorway, against the hallway where she hangs for a moment. PATRICK runs up the stairway, but is met by her collapsing body. He is pinned under her. He feels her back then sees the blood which is all over him.

PATRICK: She's dead Joe. Joe, I think she's dead.

JOE stares coldly at him. He raises the gun.

No!

JOE lowers the gun and walks back to the studio. It is a single-barrelled gun and he snaps it, and taking a shell from his pocket reloads. As he does this PATRICK crawls upstairs. He stops for a second, JOE walks up the staircase with his lower body still visible. He fires with PATRICK at his heels. There is a flash and explosion. We see JOE's body collapse. PATRICK is blinded by the flash. He collapses backwards, covering his face. When he regains his sight he sees he is covered in blood. There is a bang on the door downstairs. We hear the dustbin lids being banged.

PATRICK sits in JOE's chair, from which he opened the play, and begins to weep.

Blackout.

The End.